Abolitionism
and the
Civil War
in
Southwestern Illinois

Abolitionism
and the
Civil War
in
Southwestern Illinois

[signature: John J. Dunphy]

JOHN J. DUNPHY

History Press

Published by The History Press
Charleston, SC 29403
www.historypress.net

Copyright © 2011 by John J. Dunphy
All rights reserved

First published 2011

Manufactured in the United States

ISBN 978.1.60949.328.8

Library of Congress Cataloging-in-Publication Data
Dunphy, John J. (John Joseph)
Abolitionism and the Civil War in Southwestern Illinois / John J. Dunphy.
p. cm.
Includes bibliographical references.
ISBN 978-1-60949-328-8
1. Antislavery movements--Illinois--History--19th century. 2. Abolitionists--Illinois--History--19th century. 3. Illinois--History--Civil War, 1861-1865. I. Title.
E445.I2D86 2011
977.3'03--dc23
2011030454

Notice: The information in this book is true and complete to the best of our knowledge. It is offered without guarantee on the part of the author or The History Press. The author and The History Press disclaim all liability in connection with the use of this book.

All rights reserved. No part of this book may be reproduced or transmitted in any form whatsoever without prior written permission from the publisher except in the case of brief quotations embodied in critical articles and reviews.

for Loretta

Contents

Introduction · 9

Part I. The Struggle Against Slavery
Edward Coles and the Election That Kept Illinois a Free State · 15
Brooklyn, Illinois · 27
From Model Plantation to Liberation:
 The Journey of Dr. Silas Hamilton · 31
Elijah Lovejoy · 37
The Underground Railroad · 49
Elijah Dimmock: Second Street Abolitionist · 55
Thaddeus Hurlbut · 59
Lyman Trumbull · 63
The Lincoln-Douglas Debate in Alton · 69

Part II. The Civil War
Keeping St. Louis Firearms Out of Rebel Hands · 77
Alton's Turner Hall: A Union Bastion · 83
The Federal Military Prison in Alton · 87
Griffin Frost: Confederate Prisoner of War · 91
Mary Ann Pitman: The Cross-Dressing Spy · 95
The Confederate Underground · 99
The Thirteenth Amendment · 103

Contents

Part III. Post-Bellum
Alton's Turner Hall	107
The Nation's Oldest Memorial Day Parade	111
Griffin Frost: Newspaper Publisher and Author	113
The Political Odyssey of Lyman Trumbull	115
Thaddeus Hurlbut: The Years of Disappointment	119
Elijah Lovejoy: Abolitionist or Not?	123
The Sam Davis 803 Chapter of the United Daughters of the Confederacy	129
The Rocky Fork Church	135
The Alton Prison and Smallpox Island	137
Brooklyn	141
The Hamilton School in Otterville	143
Philip Mercer: Minister, Author, Confederate Partisan	145
Bibliography	149
Index	155
About the Author	159

Introduction

Although I was born in 1953, abolitionism has been a living, decisive force in the life of this southwestern Illinois resident. As a Mississippi River city that bordered the slave state of Missouri, my hometown of Alton was a hotbed of opposition to the peculiar institution. Unlike deep southern Illinois, which was settled primarily by families from the South and border states who had little sympathy for escaped slaves, Alton hosted a sizable population of transplanted easterners who loathed slavery. While I'm not related by blood to any of those courageous abolitionists who willingly violated the law and risked their lives to aid fugitive slaves, I feel an intimate kinship with them.

My great-uncle and godfather, the late Joe Dromgoole, served as assistant editor of our local newspaper, the *Alton Evening Telegraph*. Uncle Joe's paper had long ago adopted Elijah Lovejoy, the abolitionist newspaper editor who was murdered by a pro-slavery Alton mob, as its patron saint. I recall Uncle Joe showing me a portion of Lovejoy's final printing press, which is on permanent display inside the *Telegraph* building, and explaining the importance of a free press in the United States. I can't remember my age upon first seeing the Lovejoy Monument in Alton Cemetery. Uncle Joe (who really wasn't all that tall) towered over me at the time, however, while the Lovejoy Monument towered over both of us—and everything else for blocks.

Aunt Dot, Uncle Joe's wife, also possessed an abolitionist connection. The former Dorothy Horton had grown up in the historic Hurlbut-Messenger

Introduction

House in Upper Alton. The home had been built in 1841 for Thaddeus Hurlbut, a staunch Lovejoy ally who had stood with the embattled editor when a mob besieged the warehouse where he was defending his new printing press. Hurlbut's home served as a station on the Underground Railroad. Hurlbut sold his Upper Alton house to Aunt Dot's grandparents, Benjamin and Helen Messenger, in 1884. My great-aunt told me about the basement where fugitive slaves were hidden.

I also have a contemporary link to abolitionism. While I was born too late to save the Hurlbut-Messenger House, which was razed in 1957, my wife and I preserved another important southwestern Illinois station on the Underground Railroad by purchasing the Dimmock home in 2009. Built in 1831, this Alton house was later bought by Elijah Dimmock, who hid escaped slaves in a room adjoining the kitchen. The book you are reading was written in the Dimmock house, now known as the Dunphy Building, where an untold number of fugitive slaves first tasted freedom.

Confederate prisoners of war were incarcerated in Alton's penitentiary. Those who died were buried in a North Alton cemetery, where they were honored by a stone obelisk. When smallpox swept through the prison, an isolation hospital for infected inmates was set up on an island just opposite Alton that old-timers referred to as Smallpox Island. Uncle Joe told me stories of the place—some factual, others folklore, all supremely entertaining. Readers of *From Christmas to Twelfth Night in Southern Illinois* (The History Press, 2010) will recall Uncle Joe's hair-raising tale "The Ghosts of Smallpox Island."

Edward Coles, an expatriate Virginian who took up residence in the Madison County seat of Edwardsville, became an early governor of Illinois and campaigned to keep ours a free state. A daring military operation, made possible by Alton townspeople, crippled the Confederate cause in Missouri and helped arm Illinoisans who had enlisted in the Union army. Lyman Trumbull, a United States senator and Alton resident, wrote the Thirteenth Amendment, which abolished slavery in the United States.

Too few Americans are familiar with the people and events in southwestern Illinois that figured so prominently in the abolitionist movement and the Civil War. I decided to remedy that situation by writing this book.

All photographs were taken by me, except when credited otherwise in the captions. My special thanks to Sharon Schaefer of Alton's Hayner Public Library, Gwenith Podeschi of the Abraham Lincoln Presidential Library in Springfield and the staff of the Alton Museum of History and Art for their valuable research assistance. The United Daughters of the Confederacy

Introduction

provided me with information about the long-defunct Sam Davis 803 chapter. Dwight Phillips lent technical support in preparing this manuscript and its photographs for electronic submission. And thank you, my darling Loretta, for being my best proofreader and loving wife.

Part I
The Struggle Against Slavery

Edward Coles and the Election That Kept Illinois a Free State

Illinoisans celebrate the legacy of those Prairie State residents who played significant roles in ridding our nation of the peculiar institution. While abolitionist newspaper editor Elijah Lovejoy and U.S. senator Lyman Trumbull are remembered and revered, Edward Coles has slipped into obscurity. Born into a patrician Virginia family, he was uncomfortable with party politics and served only one term as governor of his adopted state of Illinois. He never again held elective office. Still, this erudite idealist triumphed in a grueling battle with powerful proslavery forces and ensured that Illinois would remain a free state and side with the Union during the Civil War.

The eighth of ten children, Edward Coles was born on December 15, 1786, at his family's plantation just below Virginia's Blue Ridge Mountains. The plantation's crops didn't even begin to bring in the cash needed to run such a large estate. By the first decade of the nineteenth century, the Coles family's true wealth consisted of its land—and the slaves who worked that land.

Coles enrolled in the College of William and Mary, where he studied under Episcopal bishop and college president James Madison, who was a second cousin to President James Madison. Madison required his students to read the works of the Enlightenment philosophers such as Locke, Voltaire and Paine. Coles embraced their ideas and began to question the morality of slavery in a nation so steeped in an ideology of freedom and natural rights.

Coles's growing doubts about slavery's place in a land that enshrined liberty led him to ask Madison during a lecture on the rights of man how

any person of conscience could literally own another human being. The good bishop seemed embarrassed by such a direct question but candidly admitted that it could not be justified. Coles graduated from William and Mary convinced that slavery ran counter to the ideals of the Enlightenment upon which the United States had been founded. His reading of the phrase "all men are created equal and endowed by the Creator with certain inalienable rights" from the Declaration of Independence was incompatible with the peculiar institution.

Coles knew that someday he would inherit slaves from his father's estate and decided to keep his antislavery views private. He realized that the elder Coles would leave no slaves to a son who planned to set them free. When his father died in 1808, Coles revealed his desire to liberate the slaves he had inherited. His family and friends were appalled. He had no profession open to him except that of planter, they reminded him. How could he manage without slaves?

His desire to liberate his slaves was further complicated by a Virginia law, passed in 1808, stipulating that any Virginian who freed his slaves had to move them from the state. But where? That question was deferred when Coles accepted an invitation from President James Madison to serve as his secretary. Before leaving the family plantation, however, he explicitly prohibited the overseer who had been hired by his late father from whipping the slaves.

While employed as Madison's secretary, Coles purportedly brought about a reconciliation between old enemies John Adams and Thomas Jefferson. Still, the question of slavery was never far from Coles's mind. He even wrote Jefferson to request that the former president devise a plan for the gradual elimination of slavery. Coles thought that the principles enunciated by Jefferson in the Declaration of Independence obligated its author to address this matter. Jefferson said that while his love of justice pleaded the cause of slaves and he desired their liberation, he was too old to accept such a challenge. Such a response did not sit well with Coles, who replied that he saw no reason that age should impede one as distinguished as Jefferson from addressing such a critical matter.

Coles resigned his position in 1815 and visited the towns of Kaskaskia and Shawneetown in the territory of Illinois, where the introduction of slavery had been banned by the Northwest Ordinance of 1787. He returned to Illinois in 1818—the year it was granted statehood—and spent $2,300 to purchase land, including acreage in Madison County. A year later, Coles departed Virginia on two flatboats for his holdings in Illinois. He brought

The Struggle Against Slavery

his seventeen slaves with him: five adults and twelve children. While still on the Ohio River—the natural boundary between the free North and the slaveholding South—he announced to these captives that they were free.

After a few moments of stunned silence and disbelief, the slaves began to rejoice. Coles then delivered a somewhat patronizing lecture in which he advised them to be honest and industrious, learn to read and write and observe the duties that accompany freedom. He also informed them that as long as they behaved themselves well, they could regard him as a friend. It was almost unheard of in the United States in 1819 for white citizens to refer to themselves as friends to blacks, whether free or enslaved. In doing so, Coles demonstrated that he was a man far ahead of his time.

Coles envisioned his former slaves building good lives for themselves and their families, so he knew they would need land. He announced that each adult would receive 160 acres of the land he had purchased in Illinois. They had worked as slaves for him, Coles said, and he wished to give them land by way of compensation for their labor.

Pulling ashore at Kentucky, Coles sold the flatboats and purchased a horse and wagon. He told his ex-slaves to go to Vincennes, Indiana, and stay on the National Road, which would take them to Edwardsville. Coles assured them that he would soon follow after taking care of some business. If these newly freed men and women had any trepidation about traveling through a strange countryside without their former master, Coles made no mention of it in his later writings.

Although deeply intelligent, Coles had been somewhat mistaken in concluding simply from a reading of the Northwest Ordinance of 1787 that Illinois was a state where slavery had no place. While the ordinance indeed had banned the introduction of slavery to the territory that would become the state of Illinois, it allowed the old French families that originally had settled in the region to retain their slaves, as well as the offspring of these slaves. Slaveholders who had immigrated to Illinois—such as Ninian Edwards, who would later become governor—were allowed to keep their captives. As many as two thousand slaves at a time were hired from their Kentucky masters to labor at the saltworks in southern Illinois.

The territorial legislature had passed a measure in 1812 that allowed owners whose slaves were fifteen or older to take them before a clerk of the court to have them declared indentured servants. Slaves under age fifteen could be held against their will until age thirty-five for male and thirty-two for females. The children of indentured servants could be held in bondage until age thirty for males and age twenty-eight for females.

Abolitionism and the Civil War in Southwestern Illinois

When Illinois was admitted to the Union in 1818, its constitution specified that slavery could not be introduced into the Prairie State at some later date. Illinois was a free state—in theory, at least. But the constitution also recognized the existence of "voluntary servitude," which really amounted to de facto slavery. The "contracts" of indentured servants could be freely bought and sold. Flogging was legal. Indentured servants received twenty-five lashes in the presence of a magistrate for the "crime" of being found more than ten miles from their homes.

The first state legislature passed the Black Laws, which effectively deprived blacks in Illinois of living in security and freedom. Modeled after the notorious Slave Codes of Virginia and Kentucky, the Black Laws mandated that any escaped slave entering Illinois who refused indenture within thirty days could be reclaimed by his former master and forcibly returned. In other words, escaped slaves had only the option of replacing their old masters with new ones. An escaped slave who was not reclaimed by his or her master and refused indenture could be arrested and sold into servitude for one year.

Illinois wasn't safe even for free blacks, which explains why so many escaped slaves continued traveling north after entering the Prairie State. Free blacks were required by law to record their certificates of emancipation in the courthouse of the county where they resided. Even this measure, however, did not ensure their safety. The kidnap and sale into slavery of free blacks was a common occurrence in Illinois. Law enforcement officers took little or no interest in apprehending whites who engaged in this nefarious practice.

When Coles and his newly emancipated blacks arrived in Illinois, there were about 900 slaves within its borders. Madison County, Coles's destination, contained 110 blacks: 33 who were free and 77 who were slaves.

Coles had planned his exodus from Virginia well. He had used his influence with President James Monroe to obtain an appointment as a land office registrar in Edwardsville. The position would provide him with an income of $500 per year, plus a 1 percent commission on each land sale. He bought 470 acres of land three miles east of Edwardsville and named the farm Prairieland. Each male head of Coles's former slave families received 160 acres of land in Sections 14, 15 and 16 of Pin Oak Township. In his diary, Coles wrote that he hoped they would conduct themselves in such a manner as to demonstrate that "descendants of Africa" were worthy of liberty, which would support the argument for the emancipation of all slaves in America.

These ex-slaves needed money to turn the land Coles had given them into working farms, so they hired themselves out to area farms and businesses owned by whites. Their employers cheated them by paying their wages

in almost worthless paper money. The ex-slaves were forced into debt and eventually lost their land to whites. Coles was surprised and sorely disappointed by such exploitation of blacks in a free state.

While serving as registrar, Coles became acquainted with John Messenger, a Vermont expatriate employed as a government surveyor. Messenger shared Coles's dislike of slavery and became his earliest ally. According to Messenger family tradition, it was John Messenger who suggested to Coles that he run for governor in 1822.

Coles's position in the land office had made him a prominent figure in Edwardsville and the region to the north of that community, but he was virtually unknown in southern Illinois. He visited taverns to meet potential voters and networked with local officeholders. Coles's patrician refinement and elegance decidedly set him apart from the region's rowdier residents, but the sincerity of his manner succeeded in winning over those southern Illinoisans who didn't support slavery.

The former Virginian made no secret of his opposition to the peculiar institution. He wrote two letters that were published in the *Illinois Intelligencer* that detailed how he had freed his slaves. Coles even reprinted his correspondence with Jefferson on the issue of slavery.

Coles emerged the victor in a spirited four-way race, garnering 2,854 votes and edging out runner-up Joseph Phillips, who was proslavery, by just 167 votes. A third candidate, Thomas Browne, had argued that slavery was vital to the southern Illinois saltworks and took 2,443 votes. A minor candidate, James Moore, captured just 622 votes. Moore had run as an opponent of slavery, but some scholars believe that the proslavery faction might have induced him to run simply to siphon off votes from Coles. In any event, the election tally clearly demonstrated that a majority of Illinoisans did not share Coles's opposition to slavery. Proslavery men now held twelve of the state senate's eighteen seats.

But Edward Coles was not deterred by what most politicians would have perceived as a lack of popular support. In his first address to the legislature at the state capitol, which at that time was located in Vandalia, Coles noted that the Northwest Ordinance had banned slavery and involuntary servitude in the territory that was now Illinois. One can scarcely imagine the legislators' shock when Coles recommended that they make the necessary provisions for the abrogation of slavery in Illinois.

The proslavery faction in the legislature responded to Coles's challenge by calling for a public referendum to establish a state constitutional convention that would legalize slavery. Torch-bearing mobs paraded through the streets

of Vandalia chanting what would become the motto of the pro-convention forces: "Convention or death!" Coles and a handful of antislavery men formally issued a statement that outlined their response to this movement to legalize slavery in Illinois. A powerful document, it included the declaration that "the wise and good of all nations" would be disgusted by any attempt to legalize slavery in Illinois.

The referendum was scheduled to be put to a vote in August 1824, in order to coincide with the congressional elections. The war between the pro-convention men, often referred to as "conventionists," and anti-convention factions soon raged across Illinois. Coles's allies in the struggle included Messenger, the Reverend Thomas Lippincott and Baptist missionary John Mason Peck, who would later found Shurtleff College as well as the Upper Alton Baptist Church. Morris Birkbeck, an Englishman whom Coles met while returning from Russia on a diplomatic mission for President James Madison, had migrated to Illinois and now joined the anti-convention forces.

The embattled governor stumped the state and pledged his $1,000-a-year salary to help fund the fight against slavery. Anti-convention societies were organized in a number of counties, including Bond, Monroe, St. Clair and White. Ministers who opposed slavery flocked to the anti-convention banner. Peck found no fewer than thirty clergymen in attendance at an anti-convention meeting in St. Clair County.

The pro-convention forces presented what appeared to many as a powerful economic argument for the existence of slavery in Illinois. Slaveholding planters and businessmen who wished to relocate to another state would bypass Illinois if they could not keep their human chattel. Indeed, the pro-convention men maintained, many wealthy slaveholders already had bypassed Illinois for Missouri, where slavery was protected.

Of course, sheer racism played a prominent role in the pro-convention campaign. Coles's antislavery arguments based on Jefferson's writings frequently fell on deaf ears if the hearers regarded blacks as inherently inferior to whites. For racist Illinoisans, it seemed self-evident that the statement "all men are created equal and endowed by their Creator with certain inalienable rights" referred only to *white* men.

Letter-writing to newspapers, often under pseudonyms, composed a vital component of political campaigns in early America, and missives with a pro- or anti-convention slant began deluging the state's five newspapers. Coles and the anti-conventionists were at a serious disadvantage since only the *Edwardsville Spectator*, edited by Warren Hooper, opposed the convention. The *Republican Advocate*, published in Kaskaskia; Edwardsville's *Republican*; Shawneetown's

The Struggle Against Slavery

Illinois Gazette; and Vandalia's *Illinois Intelligencer* all supported the convention. Coles and his allies managed to gain control of the *Illinois Intelligencer*, but it still left a majority of newspapers in the hands of their enemies.

The governor and his supporters remained undaunted, however, and penned numerous letters attacking the conventionists and advocating a free Illinois. Writing as "Aristides," Coles insisted that a free state contained more productive laborers than a slave state since the labor of a free man is always more productive than the labor of a slave. Although an intellectual heir of the Enlightenment, Coles was pragmatic enough to realize that most white Illinoisans were racists and would not respond to an antislavery argument based solely on moral precepts. His priority was defeating the referendum, not persuading white voters to recognize that blacks, whether free or enslaved, were fellow human beings who were entitled to equal rights—an unrealistic goal in the Illinois of 1824.

The pro-conventionists were not idle. Samuel McRoberts, a judge in Madison County, joined with General Willis Hargrave to propose that the proslavery forces establish a statewide organization to rally support for the referendum. McRoberts and Hargrave's plan called for a state central committee of eighteen conventionists that would supervise five-man committees in each Illinois county. Their scheme even reached down to the precinct level, where three-man committees would beat the bushes for votes.

Tension between the two sides reached a crescendo when the statehouse burned down on December 9, 1823. The conventionists organized a fund to replace the building and asked Coles to make a contribution. When the financially strapped governor declined, the conventionists deliberately misrepresented his refusal in order to enrage the citizens of Vandalia. A mob burnt Coles in effigy.

Coles's enemies reached their nadir the following month when they persuaded a Madison County judge to issue a summons to the beleaguered governor claiming that he owed the county $2,000 for bonds he should have posted for the ex-slaves he had brought to Illinois. The law Coles was alleged to have violated, passed just a month before his arrival in Madison County, required a bond to be posted for every slave liberated in Illinois. This bond supposedly ensured that freed slaves would not become wards of the state.

Coles had liberated his slaves while still on the Ohio River, so he could not possibly have violated this ordinance. Nonetheless, he posted the bond, although at least one anti-convention ally requested that he withdraw it. Coles retained legal counsel to pursue the matter while he returned to the fight that was engulfing all of Illinois.

This monument marks the location of the courthouse where Governor Edward Coles's enemies convicted him of illegally freeing the slaves he brought with him to Illinois.

The referendum controversy was the most divisive issue in the history of Illinois. According to historian W.T. Norton, "Families were separated, brothers opposed brothers, churches were divided, the opposing leaders went armed on the hunting…The intensity of feeling developed came perilously near civil war."

Voters trooped to the polls in record numbers on August 2, 1824. The magnitude of the anti-convention victory surely astonished Coles and his supporters. While the Saline River watershed counties of Gallatin, Pope and White strongly supported the convention, other southern counties such as Washington, Union and Marion voted against it. Johnson County was a 74–74 tie. The convention was given a hearty thumbs-down in the American Bottoms counties of Madison, St. Clair and Monroe, while Edwards County in the eastern part of the state rejected the convention by a lopsided 391 to 9. Northern counties such as Pike, Sangamon, Morgan and Greene recorded huge votes against the convention. The final statewide vote was 6,610 against a convention and only 4,972 in favor of it.

Coles's triumph was so complete that the state legislature in late 1824 passed a special bill that decisively resolved his legal problems in Madison County stemming from the freeing of his slaves. The governor's enemies in that part of Illinois made no effort to defeat the bill. After all, Madison County voters had rejected the convention by a margin of 563 to 351.

The Struggle Against Slavery

The anti-convention forces quickly dissolved, having resigned themselves to the fact that Illinois would never become a slave state. Coles, while pleased with the magnitude of his victory and mindful of its ramifications, regarded his work as undone. The old French families still held slaves, he reminded his allies, and slaves still labored in the southern Illinois saltworks region. Those opposed to slavery must fight on until this scourge was banished from Illinois once and for all.

Unfortunately, the fight against the convention had left Coles's supporters physically and emotionally exhausted, as well as financially drained. The anti-convention forces, like their adversaries, also faded away. A few old allies, such as John Messenger, remained dedicated to the eradication of slavery, but the coalition that Coles had so painstakingly pieced together was no more. As an opponent of slavery, Edward Coles now stood almost alone.

The grim fact that most Illinoisans did not share Coles's revulsion toward slavery was graphically underscored in 1826—his last year as governor—when the legislature passed a law stipulating that indentured servants who escaped their masters and were recaptured would have additional time added to their indentures. A year later, possibly as a backhanded swipe at Coles, the legislature declared that blacks—free or enslaved—could not testify against whites in court cases. Still, Coles retained a few admirers who believed the courageous former governor deserved to be honored. A new county in eastern Illinois was named for Coles in 1830.

Coles, like other early Illinois governors, was limited by law to just one term. After leaving office, he founded the first statewide agricultural society in Illinois but evidently missed politics. Coles ran for Congress in 1832 and finished third in a field of five candidates. He never again sought elective office.

Coles moved to Philadelphia and married a wealthy, well-connected and much younger woman, Sally Roberts Logan, by whom he had two sons and a daughter. His income from the sale of some of his Illinois landholdings, as well as rent from his St. Louis property, allowed the ex-governor to enjoy a comfortable and privileged life.

The former radical who had thought of his liberated slaves as friends became increasingly conservative as he grew older. He felt little sympathy for militant abolitionists and postulated that gradual emancipation was the answer to the dilemma of slavery. Coles even came to believe that freed slaves and whites could never peacefully coexist in the United States. In a public letter to former president James Monroe, Coles went so far as to suggest that liberated slaves should work for their ex-masters for wages in order to earn money for passage to Liberia.

The State of Illinois erected this memorial to Governor Edward Coles in Valley View Cemetery at the intersection of Lewis Road and Illinois Route 157, just outside of Edwardsville.

Coles still detested slavery, however, and spent much of the 1850s trying to destroy its political legitimacy by developing an argument that the Founding Fathers had been personally opposed to the peculiar institution. As one example, Coles contended that James Madison's will had stipulated that his slaves be set free but his widow, the celebrated Dolley Madison, had stymied that provision. Coles also wrote a paper, later extended into a book, dealing with the Northwest Ordinance, in which he maintained that slavery had endured in that region much longer than Jefferson had intended.

Although Coles had deliberately distanced himself from militant abolitionism, his record as governor of Illinois ensured that proslavery Americans would forever regard him as an enemy. Without any kind of power base, Coles faded into obscurity. There was a painfully ironic episode in the twilight of his life, however. Coles's younger son, Robert, moved to Virginia in 1859 and bought a farm he named the Plantation Tract. While there is no evidence that he purchased slaves to work this farm, in all likelihood he hired their labor from his relatives and neighbors who owned slaves.

Robert Coles stood by his adopted state and the Confederacy when the Civil War broke out. This Rebel warrior, whose father had played such a decisive role in keeping Illinois free of slavery and, therefore, a bastion of

the Union, was killed on Roanoke Island, North Carolina, in 1862. Edward Coles died six years later.

Although Coles is buried in Philadelphia's Woodlands Cemetery, in 1928 the State of Illinois erected a monument to this former governor in Valley View Cemetery at the intersection of Lewis Road and Illinois Route 157 (old Route 66), located just outside of Edwardsville. In 1952, the State of Illinois installed a bronze plaque to honor Coles on the property of the old Lincoln School at 1210 North Main Street in Edwardsville. In Coles's day, the courthouse where a judge ruled that he owed the state $2,000 for having freed his slaves was located at that site. The original plaque was replaced in 1998 by the Edwardsville Historic Preservation Commission.

Brooklyn, Illinois

Located in St. Clair County, Brooklyn was founded by a band of freed and fugitive slaves who made the settlement a vital link on the Underground Railroad. Unlike other early African American communities in the Prairie State that proved short-lived, Brooklyn is very much still in existence. It is the oldest African American town in Illinois—and the United States.

According to oral tradition, Brooklyn was founded in the early 1820s when eleven African American families crossed the Mississippi River to flee the slave state of Missouri. Members of these families included free men and women as well as escaped slaves. Brooklyn's location on the fertile American Bottoms offered superb agricultural prospects, and the area abounded with a variety of game. These founding fathers and mothers included Priscilla and John Baltimore, Matilda and John Anderson, Elizabeth and James Singleton, Sarah and Daniel Wilson, Josephine and Philip Sullivan, Russell Cox, Nicholas Carpenter and a Mrs. Wyatt.

The first social institution organized in this pioneer settlement was an African Methodist Episcopal (AME) church. Tradition attributes this church's founding in 1825 to the effort of the Reverend William Paul Quinn, a circuit-riding AME missionary. The small congregation originally gathered in the Baltimores' cabin. As the number of worshipers increased, Brooklyn residents built a log church, which may well have been the first AME church west of the Allegheny Mountains. This historic church, now known as Quinn Chapel, still exists in Brooklyn. Tunnels from its Underground Railroad period are beneath Quinn Chapel.

As with most oral traditions, however, the dates attributed to the founding of Brooklyn and its AME church are somewhat at odds with other sources. Brooklyn might have been established as late as 1829, and the founding of its AME church could have occurred between 1830 and 1837. The community's Antioch Baptist Church is believed to have been founded in 1838.

Brooklyn's residents fearlessly aided African Americans fleeing the shackles of slavery. Priscilla Baltimore, sometimes referred to as "Mother Baltimore" and the "Harriet Tubman of Illinois," played a crucial role in facilitating this flight to freedom. Born of a slave mother who was impregnated by her white owner—the father-in-law of the former governor of Missouri—Baltimore was already a Methodist convert when she was purchased by a Methodist missionary for $1,100. Deeply committed to her faith, Baltimore was permitted to preach to area slaves. Somehow, she earned the money to purchase her freedom from the missionary and led a group of African Americans to the site that became the town of Brooklyn.

But Baltimore was not content merely with securing her own freedom and leading a modern-day exodus to the free state of Illinois. She willingly risked capture and re-enslavement by ferrying Quinn across the Mississippi so that he could preach the gospel to St. Louis African Americans. Quinn's congregation met in members' homes and eventually evolved into St. Paul's AME Church, which enjoys the distinction of being the oldest African American church in St. Louis. When Quinn returned to Illinois, he often brought fugitive slaves with him.

Quinn's resourcefulness became the stuff of legends. When apprehended by slave catchers outside of St. Louis and brought to court, he purportedly asserted that he was a native of India and a British subject. American laws did not apply to him, he concluded in his address to the court. Incredibly, the authorities believed him. He was released and ordered to leave Missouri.

Brooklyn became a destination for slaves fleeing Missouri. These exhausted fugitives were sheltered at the AME church, Antioch Baptist Church or private homes before continuing their journey to Alton, the next stop on this leg of the Underground Railroad. As an all-black community that had assumed a position of prominence on the Underground Railroad, Brooklyn did not remain unnoticed by slave catchers. A gang of armed men invaded the town while pursuing a fugitive. The runaway was discovered in the home of Brooklyn resident William Carper. The slave catchers murdered Carper and seized the fugitive. But Carper's murder failed to intimidate the people of Brooklyn, who remained committed to assisting runaway slaves.

The Struggle Against Slavery

Ironically, this community that had been founded by African Americans formally became the unincorporated town of Brooklyn in 1837 when Thomas Osburn and four other white men platted the settlement. Why they chose "Brooklyn" as the town's name is unclear. Their motive for establishing is also a matter of conjecture. Some sources claim that Osburn and his associates were abolitionists who wanted to ensure that the settlement remained a safe haven for African Americans. A more cynical explanation has Osborn a speculator who thought that a town in the American Bottoms someday might rival St. Louis as an economic power.

From Model Plantation to Liberation

The Journey of Dr. Silas Hamilton

An impressive stone monument erected by a former slave to the white man who once owned him? It sounds like the kind of racist mythology promulgated by white supremacist groups that would have us believe slavery wasn't such an evil institution after all and that African Americans held in bondage actually loved their masters, just as portrayed in those ludicrous Hollywood films of decades past.

Strangely enough, however, such a monument really exists. It can be found in the tiny town of Otterville in Jersey County. The story behind the striking stone structure composes one of the most poignant chapters in American history.

The saga begins in the nineteenth century with Dr. Silas Hamilton, who was born in Brookfield, Massachusetts, on May 2, 1773. Later accounts would name Tinmouth, Vermont, as Hamilton's birthplace, but we now know that his family moved to that community when the future physician was about six years old. The Hamiltons could boast of an ancestor who journeyed to America on the *Mayflower*, and members of the family played roles in the American Revolution.

After taking up medicine, Silas Hamilton in 1801 married Hannah Ives, by whom he had one child, Silas Jr. The cold winters of New England bothered Hamilton, and he took his family to Tennessee, where family tradition claims he became acquainted with Andrew Jackson. But the restless Hamilton moved on, eventually arriving in Adams County, Mississippi, about 1820.

Like many New Englanders, Silas Hamilton abhorred slavery but rejected immediate abolition in favor of gradual emancipation and eventual

relocation of freed blacks to Liberia. He purchased slaves in Maryland and Mississippi to work a plantation he bought in Adams County with the intention of running it as "humanely" as possible. Hamilton naïvely believed that a plantation on which slaves were treated with kindness and dignity would serve as a model for other southern plantations and thereby rid slavery of some of its worst cruelties.

Of course, Hamilton's experiment was a wretched failure. Northern abolitionists denounced the notion of the "humane treatment" of slaves as absurd, while southern plantation owners remained unmoved by the "kindness" that Hamilton showed his slaves. Still, it was during this model plantation fiasco that Hamilton met the person who would later immortalize his memory through the Otterville monument.

While traveling by horseback through Virginia to visit his mother in Vermont, Hamilton purchased a slave boy. There are several versions of this event. The best-known account has Hamilton stopping at the Washington plantation in Virginia, where he discovered the boy weeping. Hamilton was deeply disturbed to learn that the child had been severely traumatized by the recent sale of his mother to a slave buyer from the Deep South.

Hamilton offered to purchase the boy, named George, for $100. The plantation owner, perhaps fearing that George might grieve himself to death and therefore was a poor risk as a piece of property, readily agreed. Although he now belonged to Hamilton, young George kept the surname of his former owner and would be known for the rest of his life as George Washington. A variant of this account has the boy telling Hamilton that he couldn't remember his given name, but he recalled his mother telling him stories about our nation's first president. Hamilton then decided to name the boy George Washington.

Another version has Hamilton stopping at a plantation, where the owner brought out a two-year-old slave boy wrapped in a blanket. Hamilton is said to have paid the plantation owner $100, placed George in the saddle in front of Silas Jr. and told the toddler, "Now you are with your new master." Yet another version has Hamilton purchasing a slave boy who is certainly older than two and then placing a rope around his neck. Hamilton then leads the boy along while remaining on his horse. When the *Decatur* [IL] *Herald* carried an article about Hamilton in its November 29, 1932 edition, an artist provided a drawing that graphically illustrated this account. In light of Hamilton's basic humanitarianism, however, we may safely reject this tale as completely implausible.

Washington became yet another participant in Hamilton's doomed model plantation scheme. When Silas Jr. died in 1823, the good doctor lost heart

The Struggle Against Slavery

and sold the plantation. He brought his twenty-eight slaves to Cincinnati, Ohio, and gave them their freedom. Most of these ex-slaves settled in Yellow Springs, Ohio. Three of these former captives, however, chose to remain with Hamilton—the aged Henry and Venie Walker, who served as his butler and cook, and George Washington, who was too young to make his own way in the world.

This rather unusual company made its way to New Design, Illinois, where Hamilton's nephew, Thomas Hamilton, taught school. In the spring of 1830, Thomas Hamilton and his uncle rode horseback in search of suitable land to purchase. They eventually found a site in Jersey County where a creek flowed through woods. It reminded Silas of Tinmouth, Vermont. A stream called Otter Creek ran through Tinmouth, so he named this Illinois stream Otter Creek and the surrounding area Otter Creek Prairie.

Although Silas Hamilton's wife had died in 1828 and he never remarried, the Hamilton name would continue at the Otter Creek settlement. Besides Thomas Hamilton, other members of the Hamilton family who settled at Otter Creek included Silas Hamilton's two sisters, Polly Hamilton Hurd and Elizabeth Hamilton Douglas, and their husbands, as well as his two brothers, William and Aaron. Another nephew, Daniel Hamilton, also made his home at Otterville.

Construction of the Hamilton School in Otterville was funded by a provision in the will of Dr. Silas Hamilton. The school was tuition-free and open to all students regardless of race.

Silas Hamilton periodically returned to Adams County, Mississippi, where he bought and sold land. Records indicate that he purchased four slaves—three women and one man—in 1832. Perhaps he needed them to work his Adams County land. Perhaps he bought them for the sole purpose of freeing them. We simply don't know.

Hamilton was the only physician in Jersey County, and the demands made on him were great. His health broke under the strain, and he died in 1834. In his will, Hamilton left $2,000 for the construction of a school and another $2,000 to support a teacher. This school, named in his honor, was tuition-free and open to all students regardless of race. One of its first students was none other than George Washington.

According to some sources, Hamilton had hoped that Washington would put his education to use by becoming a missionary to Liberia, but the young man remained in Otterville. Raised by Elizabeth and Gilbert Douglas after Hamilton's death, Washington made his living growing and selling grain and hay, making and hauling rails and clearing ground for his neighbors.

Following his baptism in North Otter Creek, he joined the Otterville Baptist Church, which met in the upper room of the Hamilton School. He served as the church's caretaker in addition to singing in the choir. Washington also taught Sunday school and eventually became assistant superintendent.

Since he was the only African American in the area and interracial marriages were frowned upon, Washington remained a bachelor. Having no biological family, he adopted the entire community and became known for his acts of kindness. If illness struck a family, Washington chopped wood and brought food. When tragedy struck, he dug graves without charge.

Otterville may have accepted Washington as one of its own, but other communities in the region were not so kind. The former slave was living on the Douglas farm when a horse was stolen. Search parties went in different directions to recover the animal, and Washington ventured into nearby Calhoun County. It was decidedly not a wise move. Calhoun residents vented their racism by selling into slavery any black person—whether free or a fugitive slave—who fell into their hands. Washington was duly seized and thrown into jail at Gilead, which was the county seat. Fortunately, Clarence Hamilton was able to secure his release.

Washington again encountered danger when he entered Grafton in 1860 to take a load of wheat to market. It was an election year, and a crowd of Democrats was having a barbeque. Upon seeing Washington, these Democrats quickly demonstrated their animosity toward Republicans and

The Struggle Against Slavery

George Washington, a former slave who had been owned by Silas Hamilton, had this monument to Hamilton built on the grounds of the Hamilton School.

blacks by pelting the ex-slave with rocks and gravel. Washington was rescued this time by William Shephard, a neighbor and friend.

The ex-slave frequently encountered racism but didn't allow it to embitter him. When a local white resident cursed Washington and called him a nigger, he simply informed the bigot that he wasn't worth listening to and then walked away with dignity.

When he died in 1864, Washington left $1,500 for a monument honoring his former master that was erected on the grounds of Hamilton School. Its inscription reads: "Erected by George Washington, Born a Slave in Virginia, Died in Otterville, Ill., April 18, 1864, a Christian Freeman." The base of the monument continues the inscription: "To the Memory of Dr. Silas Hamilton, His Former Master, Born at Tinmouth, Vt., May 19, 1775, Died at Otterville, Ill., November 19, 1834, Having in His Lifetime Given Freedom to Twenty-Eight Slaves and at His Death Bequeathed Four Thousand Dollars for the Erection and Endowment of the Hamilton Primary School."

The remainder of Washington's estate—about $7,000—was willed to endow a trust fund to help finance the education of African American students. Almost a century and a half later, this trust fund is still in existence. Washington, Hamilton and Gilbert Douglas are buried side by side in an old cemetery just down the road from the school.

In addition to its role as an educational institution, the Hamilton School served as a station on the Underground Railroad. Escaped slaves who made their way across the Mississippi River and found shelter at Godfrey's Rocky Fork settlement then moved on to the Hamilton School, where they rested and received food before resuming their northward journey. Washington may well have aided these fugitives.

Elijah Lovejoy

Born in Albion, Maine, on November 9, 1802, Elijah Parish Lovejoy was the eldest of nine children. His father, Daniel Lovejoy, was a Congregationalist minister who sought to instill deeply felt religious convictions in all his children and purportedly had Elijah—who was called "Parish" by his family—reading the Bible at age four. Elizabeth Lovejoy, his mother, was also a devout Christian whose few surviving letters express a profound religious fervor.

Christianity was the cornerstone of the Lovejoy family. Lovejoy biographer Merton Dillon pointed out that the Lovejoy household accepted without question the existence of absolute right and absolute wrong. The children were taught from infancy to revere the Bible, do their duty and suspect the pleasures and standards that the world called good. Dillon suggested that the propensity of the Lovejoy children for critically examining their hearts and minds to ascertain their fitness for eternity may well have inclined them to examine the society in which they lived.

Despite growing up in such an intensely religious environment, Lovejoy entered adulthood without having experienced the kind of conversion both he and his parents thought necessary for becoming a true Christian. While a twenty-one-year-old student at Maine's Waterville College (now Colby College), Lovejoy remarked in a letter to his father that he felt miserable because he recognized the importance of religion but did not possess it.

Graduating from Waterville at the top of his class, Lovejoy tried teaching in the small town of China, Maine, but found the position not challenging

enough. All America was moving west, it seemed, and the excitement of the frontier beckoned. After a brief sojourn in Boston, Elijah Lovejoy journeyed to St. Louis in 1827.

Again he tried teaching. Lovejoy opened a private classical high school that offered young people the kind of education ordinarily unavailable to those living in a town on the edge of the frontier. The academy enjoyed a modest success and even garnered a bit of capital for its founder, but Elijah Lovejoy was still dissatisfied. If teaching was not the career for him, then to what should he turn his hand?

In 1830, Lovejoy bought half-interest in the *St. Louis Times* and served as its editor for the next two years. He seemed well suited to journalism and was giving and taking barbs with rival papers in the rough-and-tumble world of the pioneer Fourth Estate. Ironically, the *St. Louis Times*, with Lovejoy at its helm, demonstrated little interest in the debate over slavery and even carried advertisements for the sale of slaves.

Lovejoy had found a rewarding and challenging career but remained tormented by a gnawing existential emptiness. The young man who had grown up in a household permeated with Christianity still believed that he did not know Christ. But there was something in the wind.

As John Gill observed in *Tide Without Turning*, the Great Revival that had peaked in western New York a few years earlier was still very much in full swing in what was then the "Far West." He correctly characterized this revival as a powerful movement with social overtones calling for repentance for national sins. Gill, who became interested in Lovejoy while serving as the minister of Alton's First Unitarian Church in the 1940s, also noted that the Great Revival carried with it the seeds for many of the nineteenth century's most important reform movements such as temperance, women's rights and abolitionism.

The First Presbyterian Church of St. Louis held a series of revival services in 1831, and while in attendance, Lovejoy apparently remained unmoved. But his Puritan background made him a prime candidate for conversion. In January 1832, the same church held another series of revivals that featured the Reverend David Nelson as the guest preacher. A powerful speaker who was not reluctant to condemn slavery as a sin that was as loathsome in the eyes of God as adultery and murder, Nelson's preaching won twice as many converts as the previous preacher. And one of those converts was Elijah Lovejoy.

Lovejoy was uncertain which path he should now take but believed that he could not continue as the editor of a secular newspaper. The Reverend William Potts, pastor of the First Presbyterian Church of St. Louis, advised the young man to enter the ministry. Lovejoy eagerly embraced his counsel.

The Struggle Against Slavery

Selling his share of the *St. Louis Times*, Lovejoy enrolled in Princeton Theological Seminary, where most Presbyterian ministers of that era were trained. He completed the course of study in just thirteen months and returned to St. Louis to accept the editorship of the *St. Louis Observer*, a religious newspaper devoted to uplifting the morals of that city's inhabitants by attacking the vices in their midst.

And attack Lovejoy did. In addition to lambasting the usual targets of the clergy such as alcohol, tobacco and moral laxity, the paper thundered against any denomination Lovejoy regarded as deviating from true biblical Christianity. Baptists, "Campbellites" (a term then applied to the Disciples of Christ denomination) and even the stately Church of England all felt the fury of Lovejoy's literary wrath. But no denomination was vilified quite as much as the Roman Catholic Church.

"Popery," as Lovejoy termed this religion, was spreading across the United States due to "foreign" influence and money, Lovejoy warned in editorial after editorial. Scholars have argued that Elijah Lovejoy was simply expressing a perspective that was held by a majority of native-born Protestant Americans at that time. Still, the blatant bigotry and narrow-mindedness expressed in Lovejoy's early editions of the *St. Louis Observer* besmirch his character to this day and detract from his reputation as a martyr to freedom.

Lovejoy took a respite from his self-appointed crusade against vice and Popery to marry Julia Ann French of St. Charles, Missouri, on March 4, 1835. In a joyous letter to his mother, the newlywed Lovejoy sang the praises of his bride to the heavens, describing her as sweet-tempered, intelligent, refined and kindhearted. Their first child, Edward Payton Lovejoy, was born twelve months later.

But changes even more momentous were occurring in Lovejoy's life. The preferred demon castigated in the pages of the *St. Louis Observer* gradually shifted during the 1834–35 period from Roman Catholicism to slavery. As one from a Yankee Calvinist background, Elijah Lovejoy had never harbored much sympathy for the peculiar institution, but now he began speaking out against it. The very first printed statement strongly critical of slavery that Lovejoy scholars have been able to find appeared in the September 4, 1834 edition of the *St. Louis Observer*. It seems that Lovejoy's old newspaper, the *St. Louis Times*, openly called for mob action against some women who had started a Sunday school for slaves. While insisting that he was no abolitionist, Elijah Lovejoy argued that slaves indeed should be taught about Christ since their souls were as precious as those of their masters.

This bust of Elijah Lovejoy was created by Hillis Arnold, an art instructor at the old Monticello College in Godfrey, Illinois. The bust is on permanent exhibit at the Alton Museum of History and Art.

In the August 16, 1835 edition of the *Observer*, Lovejoy unequivocally stated that slavery was wrong but took pains to note that he did not favor immediate emancipation, as did the abolitionists. Such a course of action, Lovejoy wrote, would be cruel to the slaves and injurious to the community at large. Lovejoy's position more or less paralleled that held by the American Colonization Society, which advocated the gradual freeing of slaves and their transport back to Africa.

A careful examination of the *Observer*, however, reveals Lovejoy's slow, steady progress toward the view that slavery was a moral obscenity that blighted America and should be swept away with all due haste. His continuing radicalization makes for some of the *Observer*'s most stirring reading. In the November 5, 1835 edition, for example, Lovejoy deplored slavery as a system that tore families apart and sold its members like so much livestock, all for the sake of financial gain.

Such strong words did not endear the young editor to the proslavery forces in St. Louis or his colleagues in the Presbyterian denomination, who began to

regard Lovejoy as an embarrassment. But Lovejoy contemptuously dismissed any suggestion that he mute his message or suffer the consequences. The constitutions of both the United States and the state of Missouri guaranteed freedom of the press, Lovejoy noted. He, not some mob, would determine the editorial content of the *Observer*, and threats would not intimidate him into silence.

In the November 5, 1835 edition, Lovejoy proclaimed that he would die at his post before he would desert it. He would soon repeat that bold statement in Alton, the city in which he lost his life.

For some time, Lovejoy had entertained the notion of relocating the *Observer* to the free state of Illinois, where he thought he could wage his campaign against slavery with relative impunity. A series of events in the spring of 1836 served to solidify that decision. It was then that a free African American named McIntosh, who had committed a murder under extenuating circumstances, was literally burned alive by a St. Louis mob. Lovejoy lost no time in denouncing this horrifying spectacle in the *Observer*, an act that further enraged the city's proslavery element. But the crowning blow to Lovejoy's St. Louis career was delivered not so much by a gang of hooligans as by the judge who presided over the court that dealt with the lynching.

The judge, ironically named Luke Edward Lawless, admonished the grand jury that, while the African American's fiery death was indeed a tragedy, it was really all the fault of Elijah Lovejoy rather than the mob that had kindled the flames. Newspapers like the *Observer*, Lawless warned, fanaticized blacks and incited them against whites. He even posed the rhetorical question of whether the press should be allowed such license.

The outraged Lovejoy replied that he would rather be chained to the same tree that held McIntosh while he was burned alive than accept Lawless's brutal vision of America. He then announced that he would relocate the *Observer* to Illinois. The newspaper plant was vandalized the next evening. Much of the printing equipment was smashed or carried off and thrown into the Mississippi. Elijah Lovejoy's Missouri career had abruptly come to an end.

It must have been with considerable relief that Lovejoy and his family entered Alton in July 1836. But mob violence followed them into this river town. The printing press and a few other items that Lovejoy had managed to salvage from his St. Louis plant were shipped to Alton by steamboat and arrived on a Sunday. Minister that he was, Lovejoy refused to perform the manual labor necessary to haul the equipment to the *Observer*'s Alton office on the Sabbath, intending to take care of the matter the next day. On Sunday

night, however, a group of men, purportedly from Missouri, smashed the printing press to bits and chucked the pieces into the Mississippi.

Desiring to solidify his position in this new community, Lovejoy attended a meeting that had been called to protest this outrage. He assured his Alton supporters that he was no radical abolitionist, despite what his opponents said. Lovejoy even went so far as to promise that the *Alton Observer* would be primarily a religious newspaper, with less space devoted to the slavery question than when it had been published in Missouri. Illinois was, after all, a free state, he noted. But Lovejoy added a proviso. As long as he was an American citizen with American blood running through his veins, he would speak, write and publish whatever he pleased on any subject.

The *Alton Observer* finally began publication on September 8, 1836, and its uncompromising tone must have persuaded most Altonians that Lovejoy had been lying when he claimed he was not an abolitionist. The editorial in that first issue proclaimed that slavery was not just an evil but a sin. It was the duty of all Americans to bring about a speedy emancipation for all who were held in bondage. Subsequent editions drove home Lovejoy's antislavery position in terms no one could misunderstand.

While antislavery was the core of the *Alton Observer*, the newspaper carried other articles of interest to the public. Regular features included a farmers' column, as well as a column for farmers' wives. The *Observer* even ran a temperance column for young people.

Lovejoy scholars have noted that even those *Alton Observer* articles that did not deal with the slavery question sometimes reflected Lovejoy's passion for justice and equality. For instance, a number of articles dealt with the plight of Native Americans, as well as the failure of Washington to keep treaties. At a time when most Americans of European descent regarded Native Americans as vermin worthy of extermination, Lovejoy had the courage to publish a story about the massacre of twelve Native American women and children by a party of what Lovejoy called "white savages."

Controversial though it was, the *Alton Observer* flourished and came to be known in almost every Illinois town and even in Missouri, Indiana and Kentucky. While editing the newspaper, Lovejoy also served as pastor of the Upper Alton Presbyterian Church (now known as the College Avenue Presbyterian Church) and taught Sunday school at the First Presbyterian Church in Alton.

Elijah Lovejoy finally rejected any reservations or qualms about abolitionism in the summer of 1837. In a July 6 editorial titled "Illinois Anti-Slavery Society," he called for the founding of a new organization. "Is it

not time that such a society be formed?" he asked. After noting that the abolitionist cause had "many, many friends" in Illinois and numerous local antislavery societies existed, Lovejoy suggested that "the time has come" to organize a statewide antislavery society.

This editorial had been written on July 4, Lovejoy remarked, but the existence of slavery mocked the notion that the United States was the land of freedom. White Americans rejoiced "while our feet are upon the necks of nearly three million of fellow men! Not all our shouts of self-congratulation can drown out their groans—even that the very flag of freedom that waves over our heads is formed from material cultivated by slaves, on soil moistened with their blood drawn from them by the whip of a republican task-master!"

A July 20 editorial called slavery a sin in capital letters and declared that profiting from the work that a slave had done was robbery. But even more controversial than those statements was Lovejoy's blunt accusation that slaveholders who attacked abolitionists as "amalgamationists" (those who advocated interracial marriage) were actually amalgamationists themselves, since female slaves were so often raped by their masters. This was a truth that was quietly acknowledged by virtually all Americans in 1837, but to shatter the vicious conspiracy of silence required a special kind of courage. It also ensured that Lovejoy's enemies would be sufficiently enraged to strike against him.

On the night of August 21, 1837, a group of men broke into the *Observer* plant, smashed the printing press and threw its pieces into the river. Money was raised for a replacement, but just one month later, a gang stole into the warehouse in which the new press was stored and dumped it into the Mississippi before it had even been uncrated.

Lovejoy refused to be intimidated, however, and allowed the founding convention of the Illinois Anti-Slavery Society to be held at the Upper Alton Presbyterian Church. Unfortunately, the organizational meeting, held on October 26, 1837, was a fiasco. Lovejoy and Edward Beecher, president of Illinois College, had invited anyone who was interested in discussing freedom of the press to attend the meeting, an error in judgment that allowed Lovejoy's enemies to pack the meeting with their own people.

Lovejoy's allies withdrew to the nearby home of the Reverend Thaddeus Hurlbut (now designated as the Old Rock House and located on the corner of College and Clawson in Upper Alton), where they finally managed to organize the Illinois Anti-Slavery Society. Hurlbut was a staunch Lovejoy ally who served as associate editor of the *Alton Observer*. Delegates elected Elihu Wolcott of Jacksonville to serve as president and Hubbel Loomis, former president of

The Illinois Anti-Slavery Society was founded at the Old Rock House in Upper Alton, which was the first southwestern Illinois home of abolitionist Thaddeus Hurlbut.

Shurtleff College in Upper Alton, as one of five vice-presidents. Lovejoy was elected to serve as corresponding secretary and Hurlbut as recording secretary. Hurlbut's handwritten minutes of the meeting were donated to the Illinois State Historical Society by his grandson in the 1920s.

The group then turned its attention to the fate of the *Alton Observer*. Should it be relocated to a city where it could be published without having its press periodically destroyed? Lovejoy argued that if freedom of the press were to have any meaning, the *Observer* must remain in Alton. A majority of the delegates agreed with him.

Meanwhile, in Cincinnati, a new printing press was being readied for shipment to Alton by steamboat. It would be Lovejoy's fourth since his arrival in Alton the previous year. It would also be his last.

On November 3, Lovejoy confronted several of his most outspoken critics at a meeting held in Alton and delivered an address widely regarded as one of the most moving and forceful in American history. Lovejoy declared that because he feared God, he stood unafraid before all in Alton who opposed him. His struggle had begun in Alton, he continued, and in Alton it would end. Lovejoy concluded his speech with the comment: "After consultation with my friends, and earnestly seeking counsel with God, to remain in Alton, and here insist on protection in the exercise of my rights. If the

civil authorities refuse to protect me, I must look to God, and if I die, I am determined to make my grave in Alton."

The realization that Lovejoy had no intention of leaving the city, coupled with the knowledge that yet another printing press would soon arrive, infuriated his Alton enemies. With his decision to remain in this city regardless of the consequences, Elijah Lovejoy effectively sealed his fate.

Lovejoy's last printing press arrived about 3:00 a.m. on November 7, 1837—the final day of his life—and was stored in the Godfrey-Gilman warehouse near the river, since the embattled editor thought the imposing stone building would provide a formidable defense against any attack. Word quickly spread through Alton that the *Observer*'s new press had arrived. By that evening, a whiskey-fueled mob that may have numbered as many as three hundred besieged the warehouse. Inside, determined to guard the press against destruction, were Lovejoy and perhaps twenty supporters. The Lovejoy band exchanged shots with the mob and wounded one of their number, who later died. Alton mayor John Krum tried to act as a mediator between the two warring factions, but his efforts came to nothing.

Suddenly, the mob seized upon a plan to set fire to the building's wooden roof to force the defenders from the warehouse. Two ladders were linked together as the mob began to chant, "Burn them out!" But as the designated arsonist began to ascend the ladders, Lovejoy and three or four defenders emerged from the warehouse, knocked over the ladders and fired shots at those nearest the building.

Again the makeshift ladder was raised, and an arsonist started to climb its rungs. Again Lovejoy and a few supporters emerged to thwart the roof's destruction. But this time the mob was prepared. The moment Elijah Lovejoy burst from the warehouse, a volley of shots rang out.

Lovejoy was struck five times: in the left arm, in the abdomen and three times in the chest. According to an eyewitness account from Thaddeus Hurlbut, "There was a light in the basement. I saw Mr. Lovejoy at the foot of the stairs coming up with both hands upon his breast, exclaiming, 'I am shot—I am shot!' He uttered no other words. He reached the top of the stairs, and then fell heavily on the floor within ten feet of me."

One of Lovejoy's allies shouted to the crowd outside that Lovejoy had been murdered. Perhaps he thought the realization of such an awful deed would fill the mob with contrition and dispel its fury. If so, he was badly mistaken. The crowd rejoiced and yelled with glee.

Several men later claimed the honor of having killed Lovejoy. Since the hated abolitionist was struck five times, it is possible that he had multiple

murderers. Ironically, three of the men were physicians. One of these three, Thomas Hope, later became the mayor of Alton.

Lovejoy's death utterly demoralized the besieged defenders, who volunteered to leave the building and surrender the printing press if they were allowed safe passage from the warehouse. The mob agreed and then promptly reneged on the agreement as Lovejoy's allies filed from the building. Witnesses claimed that mob members fired well over one hundred rounds at the press's defenders.

Hurlbut and Royal Weller, who had been wounded, remained in the warehouse with Lovejoy's body. When the press had been carted off and dumped into the river, a few curious mob members approached the bullet-riddled corpse. Suddenly, Hurlbut jerked away the handkerchief he had placed over Lovejoy's face and said, "See your work, brave men!" The men, who were anything but brave, promptly fled.

Elijah Lovejoy was buried in a field near Alton on his thirty-fifth birthday. Two of his brothers, Owen and John, were in attendance, as were a few other Lovejoy allies. Celia Ann Lovejoy, only twenty-four and pregnant with their second child, was too emotionally distraught to be present. Lovejoy's grave

The grave of abolitionist newspaper editor Elijah Lovejoy is located in Alton's City Cemetery.

was dug by "Scotch" Johnson, an aged African American who, according to a custom of the times, stained the coffin with the juice of pokeberries.

Winthrop Gilman, co-owner of the warehouse where Lovejoy and his allies made their last stand, was indicted by a grand jury, as were eleven other defenders of the *Observer*'s final press. The charge: starting a riot. Gilman, who asked to be tried separately from the other defendants, was vilified by Illinois attorney general Usher Linder, who was one of Lovejoy's many enemies. The press's defenders were fanatics, Linder argued, who intended to use the thing to disseminate abolitionist propaganda and therefore deserved everything the mob had meted out that night.

The jury deliberated only fifteen minutes before acquitting Gilman. Charges against the other defendants were promptly dropped.

Now the rioters who had murdered the abolitionist and wrecked his press were placed on trial, with Usher Linder serving as attorney for the *defense*. The outcome was really anticlimactic considering the hatred of Lovejoy that lingered in the community. Every defendant was easily acquitted.

Alton may have spat on Lovejoy's memory by releasing his killers, but the national abolitionist movement was electrified by the young editor's murder. Membership in antislavery societies skyrocketed across the United States. When the attorney general of Massachusetts denounced Lovejoy at a mass meeting in Boston as a fool for meddling in the slavery issue, a young Harvard graduate rose to defend the Alton editor. That graduate was Wendell Phillips, who later became one of the most distinguished orators in the abolitionist movement. John Brown publicly consecrated his life to slavery's destruction after hearing of Lovejoy's fate. Ralph Waldo Emerson cited Lovejoy in his essay "Heroism" as a martyr to free speech.

But Lovejoy was certainly no hero in Alton. A simple pine board with the initials E.P.L. was his original grave marker. When this vanished, his grave was lost and forgotten.

The Underground Railroad

Between the years 1800 and 1860, an estimated 100,000 American slaves escaped to freedom through the Underground Railroad. Guides, referred to as "conductors," led slaves, designated as "passengers" or "cargo," from one safe house or "station" to another. The ultimate destination for these fugitives was known as the "Promised Land," which meant freedom in either a northern state or Canada. It was a dangerous and illegal enterprise. The Fugitive Slave Act of 1793 authorized the seizure of runaway slaves and a fine of $500 levied against anyone who aided these fugitives. The Fugitive Slave Act of 1850 was even more severe. It mandated six months' imprisonment for anyone who offered shelter, food or clothing to a fugitive, as well as a fine of $1,000. Participants in the Underground Railroad also risked assault or even murder at the hands of proslavery Americans.

As a free state that bordered the slave states of Missouri and Kentucky, Illinois was destined to play a significant role in the Underground Railroad. Relatively few slaves held in Kentucky chose to attempt escape across the Ohio River into deep southern Illinois, however. That area of the Prairie State had been settled by families from Kentucky, Tennessee and other slaveholding states, and the region had a well-deserved reputation for hostility toward people of color. A white resident of deep southern Illinois was much more likely to aid in the capture of fugitive slaves than assist them in their quest for freedom.

The region of Illinois that bordered the Mississippi River, however, was a different matter. Many families from eastern states had settled in this area,

and unlike residents of deep southern Illinois, they had no particular sympathy for the peculiar institution. Their willingness to assist runaway slaves made this region fertile ground for the Underground Railroad.

The Mississippi River towns of Alton, Chester and Quincy were the three principal Illinois communities that served as points of entry for slaves escaping from Missouri. My hometown (Alton), as well as the small communities to its north, provided numerous safe houses for these fugitives.

Historians believe that there were three primary routes through which escaped slaves entered Alton. The first route began at the foot of Henry Street, from where slaves made their way to the apothecary shop of George Wiegler, which was located at the present site of the Elfgen Building. Tunnels linked Wiegler's building to the waterfront, while the building itself contained rooms capable of concealing the slaves. The brokerage office of William Wade, located on what is now East Broadway, was also linked to Wiegler's building by a tunnel. Yet another station was located at Dr. Emil Guelich's residence on the corner of East Fourth and Henry Streets.

The slaves were transferred from these stations up the ravine of Shield's Branch, a small creek that ran through Hunterstown (the present East End of Alton), to Upper Alton, where further stations were located. Hunterstown was founded by Charles Hunter, who actively participated in the Underground Railroad. The Old Rock House on College Avenue, where the Illinois Anti-Slavery Society was founded, was probably the most active station. The

Built in 1831, the Dunphy Building at 16 East Broadway in Alton was once owned by abolitionist Elijah Dimmock, who made it a station on the Underground Railroad.

The Struggle Against Slavery

Hurlbut-Messenger House on Washington Avenue, the Cartwright House on Jersey Street, the Priests' Retreat on Edwards Street and a residence on Judson Street were also stations where slaves could find food and lodging. Shurtleff College in Upper Alton—now the Southern Illinois University School of Dental Medicine, as well as the site of the Alton Museum of History and Art—also served as a station. From Upper Alton, slaves could be transported to the Montgomery House, located at the current site of the St. Louis Regional Airport in Bethalto, before being moved to Springfield or Decatur.

The second Underground Railroad route in Alton began at the Dimmock House on Second Street. The site now houses the Second Reading Book Shop on its first floor, while its second floor is an apartment. The Enos Apartments building on East Third Street, one block north of the Dimmock House, is often visited by those researching the Underground Railroad. The foundation of the building is fifteen feet below street level. The basement still contains large tunnels that have now been bricked off. A cupola on the building's roof is said to have been used as a signal post. One light in the cupola alerted slaves and conductors on the Missouri side of the river that all was well for a crossing, while two lights meant that law authorities or slave catchers were in the vicinity.

The Enos Apartments Building on East Third Street in Alton was an important station on the Underground Railroad.

The third Underground Railroad route in Alton began with a series of caves in the bluffs. Conductors then led the slaves to such stations as the Post House on State Street. Another Christian Hill (a popular name for State Street) stopover for escaped slaves was the Ursuline Convent on Danforth Street. Construction workers in 1938 discovered beneath the first floor a room with only one entrance—through a trapdoor. The room, while only fifteen by eight feet, was thirteen feet deep. When a priest's residence on Danforth Street was razed in 1963, workmen found a hidden cellar that would have served well for the concealment of slaves. A house, since demolished, on Summit Street supposedly contained a tunnel that stretched to the river itself.

Most of Alton's Underground Railroad tunnels collapsed during the years following the Civil War. Others were filled in or simply had their entrances sealed off by the new property owners when residences changed hands.

Brighton also played a pivotal role in the success of the Underground Railroad. Thomas Brown, a prominent Brighton physician, offered his home as a station. Runaway slaves followed a tributary of the Wood River to an area currently part of Betsey Ann Park. If a lantern shone outside Brown's nearby house, slaves knew it was safe to journey to the residence for sanctuary. The slaves were hidden in Brown's home and in an attic over a shed.

The next Brighton station was the Hill residence, which is now the site of Brighton's branch of the State Bank of Jerseyville, followed by Herman Grigg's home, the current site of Robings Manor Nursing Home. This human cargo was then delivered to Peter Van Arsdale's house and on to the Palmer House. According to Brighton historian June Wilderman, the Palmer House had a tunnel that entered the basement, as well as tunnels that ended in the front yard.

Slaves at the Andrews House were hidden in a small cistern in the kitchen floor. The final Brighton station was a residence owned by John Hart, who took responsibility for transporting slaves to Carlinville. Several unsuccessful attempts were made on Hart's life by those enraged at his efforts to help secure freedom for enslaved men and women.

Godfrey was another hotbed of Underground Railroad activity. Don Alonzo Spaulding, a Vermont native who loathed slavery, moved in 1828 from Ebenezer, a Methodist campground near Edwardsville, to the Rocky Fork area of southwest Godfrey. He served as surveyor for Madison County and owned a steam sawmill, which was the first manufacturing business in Alton. He sold this sawmill in 1834 and built one near his home. A devout

The Struggle Against Slavery

Christian, Spaulding was one of the founding members of Upper Alton Baptist Church, where he served as a deacon.

Under Spaulding's ownership, the Rocky Fork community became a destination for runaway slaves who crossed the Mississippi, turned up Piasa Creek and then followed Rocky Fork Creek to this safe haven. Rags tied to trees also assisted slaves in their quest to find Rocky Fork. Two old hollow trees were particularly important. One of these trees, called the Mail Tree or Message Tree, was located near that stretch of Illinois Route 3 that southwestern Illinois residents often call Old Route 100. As its name implies, messages were left in the Mail Tree. The other tree, known as the Slave Tree, was located near Rocky Fork Creek and contained information about Underground Railroad stations.

Local historians also mention the Hanging Tree, which was located in the Rocky Fork area. Slave catchers from Missouri caught a runaway slave and, rather than returning him, hanged the slave from the tree. Perhaps the slave catchers left his body dangling to warn the other fugitives living in the area that they would suffer the same fate if captured. The tree was struck by lightning many years ago and then cut down.

Spaulding's sawmill provided jobs for these fugitives, and the former slaves began to homestead at Rocky Fork. Harry Spaulding, Don Alonzo Spaulding's brother, also resided in the area. Harry served as a justice of the peace, and his presence provided a measure of security for the fledgling settlement.

Permanent residents of Rocky Fork served as conductors who brought over slaves from Missouri. These escapees could remain at Rocky Fork or, more likely, continue their journey north. While no written records exist, it is estimated that hundreds of escaped slaves passed through Rocky Fork. Some historians believe that many slaves who first tasted freedom upon reaching Rocky Fork could well have been ultimately guided to the farm of Ira Spaulding in Sylvan, Michigan. Ira was Don Alonzo Spaulding's first cousin and an ardent abolitionist who facilitated fugitive slaves wanting to enter Canada, where slavery was illegal after 1833.

The secluded location of the Rocky Fork settlement worked to ensure that many area residents were unaware of its existence. It seemed to those who chanced upon it nothing more than a community of free blacks who lived in widely dispersed cabins and worked at Spaulding's sawmill. Ironically, this subterfuge worked so well that even today many southwestern Illinois residents believe that Rocky Fork was founded by free blacks before the Civil War or slaves who had been freed during the Civil War.

Slave catchers, however, were indeed aware of Rocky Fork as a refuge for fugitive slaves. Dr. Benjamin "Franklin" Long owned Sylvan Grove farm on Grafton Road, which his descendants say was the first Underground Railroad stop for slaves who had escaped from Missouri. Long family tradition maintains that gun battles sometimes broke out between slave catchers and Rocky Fork residents, assisted by their white allies who lived along Grafton Road, as Old Route 100 was then called.

Rocky Fork had its own graveyard, as well as an outdoor campground where religious services were performed. The worshipers became the nucleus of an African Methodist Episcopal church congregation at the Rocky Fork settlement. The congregation erected its first church building in 1863 to mark the Emancipation Proclamation. Arasmus Green, a veteran of the Union army's Colored Infantry Volunteers, served as the church's first minister.

Elijah Dimmock

Second Street Abolitionist

Like Lovejoy and Hurlbut, Dimmock was a New Englander, born in Falmouth, Massachusetts, on September 15, 1802. A teacher by profession, he married Sarah Phinney in 1827. The Dimmocks had five children, two of whom lived to adulthood: Thomas and Sophronia. When they moved to Cincinnati in 1838, they brought with them three of Sarah's siblings: Charles, Mary and Susan. Two years later, the Dimmock-Phinney family took a steamboat to Alton, where it put down roots.

Alton was a rough river town in those days and a far cry from the relative gentility of the Old Bay State. Upon catching their first glimpse of this Mississippi River town, all three women began to weep. The year 1840 was a hard time in Alton: an epidemic of "chills and fever" swept through the population, while a drought emptied the town's wells. An old account, however, notes that "the people they met in Alton were delightful and every one helped the newcomers."

Elijah Dimmock abandoned teaching for business and soon established a wholesale shoe enterprise. But Dimmock shared something else with Lovejoy and Hurlbut besides birth in New England. He, too, was an abolitionist.

The Dimmocks purchased a handsome two-story brick home on Second Street (renamed Broadway in 1916) that had been built in 1831 in the Federal style. Elijah Dimmock made this house a station on the Underground Railroad. There was a room behind the kitchen that had no windows, which made it a perfect hiding place for fugitive slaves during the day. When night fell, Dimmock or another abolitionist would drive the slave by buggy to the next station.

Abolitionism and the Civil War in Southwestern Illinois

Above: Elijah and Sarah Dimmock moved to Alton in 1840. Much to his wife's consternation, Elijah gave shelter to fugitive slaves. *Courtesy of Cathy Bagby.*

Below: An early photo of the Dimmock residence. Located near the Mississippi River, this house became a destination for slaves who had fled from Missouri. *Courtesy of the Alton Museum of History and Art.*

The Struggle Against Slavery

Sarah Dimmock was well aware of the dangers associated with participation in the Underground Railroad. When Susan, her sister, visited, she would often find Sarah crying with fear. She would point to the kitchen and say, "He's got one in there!" Her fears were not misplaced. On at least one occasion, a slave catcher who came to Alton in pursuit of a fugitive angrily confronted Dimmock and even threatened his life. "For many years," according to an old memoir, "the family lived under a constant nervous strain." The same could be said of any family that aligned itself with abolitionism.

Elijah Dimmock died in 1887; Sarah Dimmock died in 1893. Their son Thomas shared his father's commitment to abolitionism and probably participated in the Underground Railroad. Although Lovejoy's murder occurred before their arrival in Alton, both father and son revered the memory of the abolitionist newspaper editor.

Thaddeus Hurlbut

Virtually everyone in Illinois is familiar with Lovejoy, but few have heard of Thaddeus Hurlbut, who was Lovejoy's most determined ally and a distinguished abolitionist in his own right. Born in Charlotte, Vermont, in 1800, he graduated from Hamilton College in New York and studied for the ministry at Andover Seminary. He and his wife, the former Abigail Paddock of Barre, Vermont, moved in 1834 to St. Louis, where Hurlbut met fellow Presbyterian minister Elijah Lovejoy. Two years later, the Hurlbuts moved to Upper Alton, which was a separate community from "lower" Alton at the time, and took up residence at the Old Rock House.

When a mob, enraged by Lovejoy's antislavery editorials, ransacked the office of the *St. Louis Observer*, Hurlbut suggested that he relocate the newspaper to Alton. He became the *Alton Observer*'s associate editor, co-founded the Illinois Anti-Slavery Society and remained with Lovejoy's bullet-riddled corpse in the Godfrey-Gilman warehouse on the night his friend was murdered.

Hurlbut considered ordering yet another printing press to continue publishing the *Alton Observer* with himself as editor, but anti-abolitionist sentiment still ran high. A mob stoned his home and even threatened his wife. After a brief sojourn in Jacksonville, Hurlbut returned to Upper Alton and had a house built on Manning Street, which we now call Washington Avenue. This home became known as the Hurlbut-Messenger house, located at 1406 Washington Avenue, one of the lost historic and architectural treasures of downstate Illinois.

Built in 1841 for Thaddeus Hurlbut, the Hurlbut-Messenger House in Upper Alton had a large basement where fugitive slaves were hidden. The author's great-aunt grew up in this house, which was razed in 1957.

Hurlbut's only son was born in this house in 1841. Lovejoy's old ally demonstrated his commitment to the antislavery movement by the name he gave to this boy: Wilberforce Lovejoy Hurlbut. William Wilberforce was the English abolitionist who had spearheaded the drive to ban slavery throughout the British Empire. The Hurlbuts also had two daughters: Ellen Mary Isabella (1834–1880) and Francese Abi (1838–1924).

Thaddeus Hurlbut preached at various churches and taught school until 1847, when he became pastor of the Upper Alton Presbyterian Church—the same church where Lovejoy had served as pastor—and preached from its pulpit until 1852. His true occupation, however, was aiding escaped slaves on their flight to freedom.

The Hurlbut-Messenger House became a stop on the Underground Railroad. An old account mentions "the dark, damp, cavernous basement" where slaves were hidden. The late George Berry, who grew up in the house in the early twentieth century, stated that as a child he had explored a long tunnel that ran from this basement. I found references to a tunnel that ran from the corner of East Fourth and Henry Streets in lower Alton and ended at the Old Rock House—a distance of about a mile and a half. Could this have been the tunnel that Berry explored?

The Struggle Against Slavery

Captain Wilberforce Lovejoy Hurlbut, the only son of Thaddeus and Abigail Hurlbut, left Upper Alton's Shurtleff College during his senior year to enlist in the Union army. *Courtesy of Nancy Alexander.*

 The Republican Party was founded to oppose the extension of slavery in the United States. Hurlbut's abolitionism led him to attend the 1854 convention that established this new party in Illinois. He served on the resolutions committee and remained a loyal Republican for the rest of his life.

 Wilberforce Lovejoy Hurlbut enrolled in Upper Alton's Shurtleff College, where he excelled in Greek and mathematics. Against his parents' wishes, he left Shurtleff in the middle of his senior year in 1862 to enlist in the Union army. Young Hurlbut fought at Antietam, led the Fifth Michigan Regiment at Chancellorsville and was wounded at Gettysburg. He went missing in action on May 6, 1864, during the Battle of the Wilderness, one of the bloodiest engagements of the Civil War, and was reported last seen leading a charge against the Confederates. Union general Isaac Richardson contacted Confederate general James Longstreet to inquire about Hurlbut's fate. Longstreet replied that Hurlbut was not incarcerated in any of the South's prisoner of war camps. Finally, an eyewitness was located who stated that he had seen young Hurlbut shot in the head. Union general Thomas F. Meagher praised the fallen warrior by saying, "With Hurlbut fell the fittest historian of the Army of the Potomac."

Lyman Trumbull

Even those with an interest in the struggle against slavery are often unfamiliar with the life and career of Lyman Trumbull. Born in Colchester, Connecticut, in 1813, Trumbull's father had graduated from Yale and served in the state legislature, while his mother was a descendant of Increase Mather, the Puritan clergyman. After graduating from Bacon Academy in Colchester, Trumbull became a teacher and journeyed to Georgia. He developed an interest in law and began studying under Hiram Warner, who would later serve on the Georgia Supreme Court. Trumbull then moved to Illinois and settled in Belleville. In 1837, he joined the law office of Congressman John Reynolds, a former governor of Illinois. Later that year, Trumbull wrote to his father regarding the murder of abolitionist newspaper editor Elijah Lovejoy.

Lovejoy's brutal murder, Trumbull speculated, would strengthen the abolitionist cause to a far greater degree than his newspaper editorials could have done. Had he been in Alton, Trumbull informed his father, he would have marched to Lovejoy's rescue, although he personally disagreed with the late editor's support for the immediate emancipation of slaves.

Trumbull's subsequent actions, however, seemed to contradict his reservations about abolitionism. Following Lovejoy's murder, he traveled throughout southern Illinois to deliver public lectures against slavery. He also collected signatures on a petition that demanded an end to the slave trade between states as well as the abolition of slavery in the District of Columbia.

Trumbull's activism was not well received by proslavery Illinoisans. The day after delivering a ringing antislavery address in Griggsville, he was assaulted and viciously kicked by a mob. Trumbull remained undaunted, however, and joined a group of antislavery lawyers who were trying to end slavery in Illinois. The group, which included Abraham Lincoln, charged no fee when taking the cases of blacks held as indentured servants. These attorneys believed that any form of indentured servitude—including slavery—was illegal in Illinois and hoped that the Illinois Supreme Court would declare it illegal.

Trumbull was elected to the Illinois legislature as a Democrat in 1840 but resigned in 1841 to accept an appointment as Illinois secretary of state to replace Stephen A. Douglas, who had left that post to serve on the Illinois Supreme Court. Trumbull was asked by Governor Thomas Ford to resign in 1843, when the two fell into a dispute over the state's debt crisis. Now out of office, Trumbull was free to turn his attention toward eradicating slavery in Illinois. A new court case seemed to offer him the opportunity to do precisely that.

Sarah Borders, a black woman who was held as an indentured servant by Andrew Borders in Randolph County, Illinois, managed to escape with her three children in 1842. They got as far north as Peoria County before all four were arrested and jailed as fugitive slaves. A justice of the peace ruled that they had been illegally detained and were entitled to their freedom. But Andrew Borders appealed the decision, and it was overturned.

The case eventually went to the Illinois Supreme Court, where Trumbull argued for Sarah Borders and her children. Slavery was illegal in Illinois under the Northwest Ordinance of 1787, Trumbull asserted, and the woman and her children should be freed. The court, however, decided in favor of Andrew Borders. Trumbull was disappointed but decided to challenge slavery in Illinois through another prominent case.

In 1842, Joseph Jarrot, a slave, filed suit against Julia Jarrot, his mistress, for wages that he believed he should have received. Joseph Jarrot's grandmother had been a slave held by this French family in the Northwest Territory before the passage of the Northwest Ordinance. While slavery in the Northwest Territory had indeed been abolished by the ordinance, legal authorities generally held the opinion that it did not apply to slaves who had been held by French settlers in the territory before the ordinance was passed. This meant that even the descendants of these French-held slaves remained in bondage.

A St. Clair County jury found for Julia Jarrot, but Trumbull took the case to the Illinois Supreme Court, where he represented Jarrot without fee. In a five-to-four ruling, the court decreed that any slave who had been brought

The Struggle Against Slavery

into Illinois since the Northwest Ordinance of 1787 was free and could sue to recover wages while kept in servitude. The remaining French-held slaves and their descendants were finally liberated.

The year 1843 was also significant for Trumbull but quite apart from politics and court cases. He married Julia Marie Jayne, a graduate of Monticello Female Seminary in present-day Godfrey, Illinois, and daughter of a prominent Springfield physician. Mary Todd Lincoln served as bride's attendant at the wedding. Ironically, Mary had once set her sights on Trumbull, confiding to a friend in a letter written in 1841 that she found the rising young politician attractive and intended to "lay claim" to him. But she had married the future president in 1842. Mary had chosen Julia Jayne as her bridesmaid.

Trumbull remained married to Julia until her death in 1868. Three sons from that marriage would survive him. In 1877, Trumbull married Mary Ingraham. The couple had two daughters, both of whom died in childhood.

Trumbull enjoyed the dubious distinction of losing two elections in 1846. He was defeated in his attempt to win the Democratic nomination for governor and then lost the general election for a congressional seat representing the Eighth District.

The Lyman Trumbull home, located on the corner of Henry and Union Streets in Alton, is a National Historic Landmark.

His fortunes changed in 1848, when he was elected to the Illinois Supreme Court. A year later, he purchased from Benjamin Ives Gilman the residence now known as the Lyman Trumbull House in Alton. The property included three acres of land with an orchard of fruit trees. The cost was $2,500, which Trumbull paid in cash from his savings. He told his father that living in Alton appealed to him because most of its three thousand residents were from eastern states. The Lyman Trumbull House, located at 1105 Henry Street, was placed on the National Register of Historic Places in 1975 and is now designated a National Historic Landmark.

Trumbull was reelected to the supreme court in 1852. He resigned from the court two years later and won a congressional race. Before he could take his seat, however, he was elected to the U.S. Senate in a bitter, three-way contest. James Shields, the Democratic incumbent, was a strong supporter of the recently passed Kansas-Nebraska Act, which had been introduced into the senate by Stephen Douglas, the Prairie State's other senator. The Kansas-Nebraska Act allowed the residents of those territories to decide whether they wanted slavery within their borders. Trumbull, still a Democrat, ran as an opponent of the act. The third candidate in the contest was the Whig nominee Abraham Lincoln, who also opposed the act.

Lincoln received forty-five votes on the first ballot, while Trumbull received only five. By the ninth ballot, however, Lincoln's support had fallen to just fifteen votes, while Trumbull drew thirty-five. Lincoln wanted a fellow free-soiler to win, so he threw his support to Trumbull. The Alton attorney won the election on the next ballot by just one vote. Mary Todd Lincoln never forgave Trumbull for depriving her husband of a senate seat.

As a senator, Trumbull quickly earned the respect of political ally and foe alike with his keen intellect and profound knowledge of the law. During a debate, he asserted that Congress possessed the same power over a territory as a state legislature has over a state. This implied that Congress could abolish slavery in the territories, if it wished to do so. When an opponent challenged him on this point, Trumbull had a Senate attendant bring him a specific volume of the *Supreme Court Reporter*. He then turned to the correct page and read aloud the words of Chief Justice John Marshall, which corroborated his statement.

Trumbull's opposition to slavery made it impossible for him to remain in the Democratic Party. He attended a Republican convention held in Bloomington, Illinois, on May 26, 1856, and was instrumental in framing resolutions that reaffirmed the right of Congress to outlaw slavery in

The Struggle Against Slavery

the territories and urged the admission of Kansas to the Union as a free state. Trumbull supported Republican candidate John C. Fremont in the presidential election of 1856, as well as Lincoln in the race of 1860. In 1861, Trumbull was reelected to the Senate as a Republican.

The Lincoln-Douglas Debate in Alton

A majestic three-story structure located near the Mississippi River, at the end of Market Street, Alton's old city hall was completed in 1859 after two years of construction. "Old City" served the community well until the building was gutted by fire in 1924.

Its top floor was once used as the city's theater, while the basement provided rather inhospitable accommodations for Alton's malefactors. Some cells, according to an old newspaper account, were as dark and deep as the dungeons of medieval prisons. The northwest corner of the building's first floor housed a highly touted saloon, much to the dismay of "dry" church groups, which never tired of arguing that the presence of a dram shop in Alton's city hall was hardly conducive to good government.

Old City figured prominently in local, state and national politics. Candidates for public office, including several presidential nominees, addressed throngs from this landmark. President Andrew Johnson is said to have once stopped at Old City. William Jennings Bryan held a crowd spellbound there with his peerless oratory. Yet Old City's true crowded hour occurred on October 15, 1858, when it hosted the last debate between Abraham Lincoln and Stephen Douglas as they contended for an Illinois senate seat.

The Alton debate was their final scheduled confrontation. Lincoln and Douglas had crossed verbal swords in Ottawa (August 22), Freeport (August 27), Jonesboro (September 15), Charleston (September 18), Galesburg (October 7) and Quincy (October 13). Both men traveled by boat from Quincy and arrived in Alton well before daylight. Lincoln took a room at the

Franklin House on State Street, while Douglas lodged at the nearby Alton Hotel. Estimates of the crowd that gathered to hear the debate vary from five to ten thousand.

Douglas, who was nicknamed the "Little Giant," delivered the opening address and promptly attacked his opponent's "a house divided against itself cannot stand" comment, which he had made in a Springfield speech on June 16 of that year. Douglas distorted the statement to mean that there must be a monolithic uniformity in local laws in every state of the Union, a prospect that every Democrat—and even some Republicans—found alarming. Slave states and free states could continue to exist in mutual harmony, he argued. The federal government had no more right to interfere in the business of slave states than it had the right to interfere in the business of those states that had outlawed slavery.

Tailoring his address for an Alton audience, Douglas accused Lincoln of sharing Elijah Lovejoy's belief that the "Negro" was the equal of the white man. The Little Giant maintained that Negroes and other "dependent races" should be given all the rights that they could exercise without jeopardizing the safety of American society. Each state must determine for itself the extent of the rights it granted to Negroes, Douglas concluded.

These life-size statues of Abraham Lincoln and Stephen Douglas are located on the site of their final debate, which occurred in Alton on October 15, 1858.

The Struggle Against Slavery

Douglas's denigrating remarks regarding Lovejoy were surely appreciated by Alton mayor Thomas Hope, who was present at the debate. Hope often boasted that he had killed Lovejoy when the embattled editor was defending his final printing press.

In his reply, Lincoln took Douglas to task for insisting that the phrase "all men are created equal" in the Declaration of Independence did not include Negroes. He also vigorously defended his "house divided" comment, sardonically observing that Douglas had warred on that speech in much the same manner that Satan wars on the Bible.

Lincoln then argued that Douglas was fighting a straw man when he portrayed the Republican candidate as opposing the right of states to do as they pleased regarding slavery. The issue, Lincoln maintained, was slavery in the new territories.

While the future president was careful to distance himself from abolitionism, he didn't hesitate to denounce slavery as "a great evil." Slavery, Lincoln contended, was an inherently divisive issue in American life. Just two years earlier, he noted, Alton's Unitarian church had been disturbed by the slavery crisis.

Lincoln didn't mention precisely *how* slavery had disturbed the Unitarian church, perhaps assuming that an Alton audience was quite familiar with this local issue. Old records indicate that the Alton Unitarians in 1853 had hired the Reverend William D'Arcy Haley as their minister. Haley, a recent graduate of Meadville Theological School, possessed a strong social conscience and was not hesitant to address controversial contemporary issues—including slavery, which he vehemently opposed—in his sermons. A particularly forceful sermon delivered in 1856 polarized the congregation, which strongly criticized Haley. He tendered his resignation, which was accepted by the Unitarian church's board of trustees by a four-to-three vote. But a heated debate among board members led to a proclamation that established "freedom of the Alton pulpit on an equal with the freedom enjoyed in all Unitarian churches in less bigoted communities." The church then asked Haley to withdraw his resignation and remain as minister, which he did. But Haley again resigned after only four months and moved to the District of Columbia. He later served as chaplain for the Seventeenth Massachusetts Volunteers during the Civil War.

History fails to record how Alton reacted upon being characterized as a bigoted community by the Unitarian Church Board of Trustees. But Lincoln's mention of this controversy that so disrupted a southwestern

Illinois church graphically underscored the divisiveness of the slavery issue in pre–Civil War American society.

The debate closed with Douglas's rejoinder, in which the Little Giant repeated his pronouncement that the federal government had no right to interfere with slavery. If slavery indeed had become a divisive issue, it was because "agitators" had made it so.

The Great Commoner lost the November 2 election, although his party captured a greater portion of the popular vote than the Democrats. United States senators were elected by state legislatures in those days. Illinois had not been reapportioned since 1852, leaving the fast-growing Republican strongholds in northern Illinois woefully underrepresented. Consequently, the vote in the Illinois House of Representatives was thirty-five for Lincoln and forty for Douglas. The Illinois Senate went eleven for Lincoln and fourteen for Douglas.

After his defeat, Lincoln expected to slip into obscurity. But the race had made a national figure out of the previously unknown Republican. The following year saw Lincoln embark on a series of speaking engagements in Wisconsin, Iowa, Indiana, Ohio and Kansas. By 1860, he was a viable darkhorse candidate for the Republican presidential nomination.

Douglas's victory over Lincoln proved quite costly. During their Freeport debate, Lincoln had asked Douglas a question that struck at the Democrat's political Achilles' heel. He had inquired whether Douglas thought that the people of a territory could lawfully exclude slavery prior to the formation of a state constitution. Douglas had replied that slavery could not exist within any territory if the citizens didn't pass the necessary laws to protect and police slave property.

The Little Giant's response was anathema to southern Democrats, who nominated their own presidential candidate in 1860. Running as the candidate of the northern Democrats, Douglas was defeated by his Republican rival of 1858. When the Civil War broke out, however, Douglas's loyalty to the Union was such that Lincoln sent him on a speaking tour to muster support for the North. In an address to the Illinois legislature in Springfield on April 25, 1861, Douglas proclaimed: "When hostile armies are marching under new and odious banners against the government of our country, the shortest way to peace is the most stupendous and unanimous preparation for war."

In a speech delivered in Chicago shortly before his death on June 3, 1861, from typhoid fever, Douglas laid it on the line: "Every man must be for the United States or against it. There can be no neutrals in this war—ONLY PATRIOTS and TRAITORS."

The Struggle Against Slavery

The site of the Alton debate is known as Lincoln-Douglas Square and features life-size statues of Abraham Lincoln and Stephen Douglas. The Little Giant is depicted as addressing the crowd, while Lincoln thoughtfully ponders Douglas's words.

Part II
The Civil War

Keeping St. Louis Firearms Out of Rebel Hands

As a slaveholding border state, support for secession ran high in Missouri. Like deep southern Illinois, Missouri had been settled by families from slaveholding states who still identified with the South and wanted the Show-Me State to join the Confederate States of America. Governor Claiborne Jackson and many members of the state legislature were pro-Confederate, although Missouri was officially neutral.

St. Louis, founded by the French in 1673, was more cosmopolitan, with a population that included immigrants from Germany and Ireland. Still, secessionists composed a strong presence in the Gateway City, and the April 12, 1861 firing on Fort Sumter galvanized them into taking action that would put Missouri in the Confederate column.

These secessionists cast their eyes on their city's arsenal, post office, customhouse and subtreasury as targets for seizure. The federal arsenal was an especially enticing target. If the secessionists could take control of the arsenal, its weapons could be issued to Confederate forces. The secessionists of St. Louis relished the irony of Union troops being slain by firearms that had originally been intended for their own use.

Captain Nathaniel Lyon, commander of the arsenal, realized the tenuousness of his position and sent a messenger to Illinois governor Richard Yates to suggest that its firearms and ammunition be removed and sent to Springfield for issue to the Unionists who were gathering in that city in response to Lincoln's call for volunteers. Yates agreed and, without even bothering to contact Washington for official approval,

delegated the task of rescuing the arsenal's weapons to Captain James Stokes.

A native of Maryland, Stokes graduated from West Point in 1835 and rose to the rank of captain and assistant quartermaster in the regular army. He resigned in 1843 to engage in business, only to reenter the army as the nation moved inexorably toward civil war. Stokes readily accepted Yates's request for assistance in bringing the arsenal's contents to Springfield. The young captain, however, realized the difficulty of such a mission.

Since news of the firing on Fort Sumter had reached St. Louis, the arsenal had been besieged by secessionists who vowed to prevent the small Union detachment from leaving with that store of arms or allowing any federal forces from entering the arsenal to bolster its defense. Secessionists had also installed a battery on Powder Point, which overlooked the arsenal. The mere threat of bombardment, the Rebel sympathizers reasoned, would surely persuade Lyon to surrender the contents of the arsenal. Another Rebel battery stood ready at the St. Louis levee.

Stokes devised a brilliant and daring plan that called for courage, coordination and a bit of calculated deceit on his part. After arriving in Alton, he sought out O.P.S. Plummer, the telegraph operator for the Chicago and Alton Railroad. The telegraph would provide the sole means of communication between Stokes and Alton, so the captain had to be sure of the operator's loyalty to the Union. An old newspaper account described their initial encounter in this manner: "In putting some decoy secession questions to the young operator, he [Stokes] came near being ejected from the office. The young fellow would not stand for it."

Now satisfied that Plummer could be trusted with sensitive messages, Stokes chartered *The City of Alton*, a large steamer. He told the captain, Leander Mitchell, to "steam up" the vessel and await further instructions that would come in a telegram delivered by Plummer. Trading his army uniform for civilian clothes, Stokes went alone to St. Louis on April 24 and made his way to the arsenal. He portrayed himself to the besieging crowd as a fellow secessionist and was permitted to enter.

Upon meeting Lyon, he presented the papers issued by Yates that authorized him to remove the arsenal's weapons to Springfield. Lyons expressed doubt that Stokes could successfully remove such a large shipment of arms in the presence of so many secessionists but agreed to assist Stokes with his plan. Stokes ordered the arsenal's telegraph operator to contact Plummer with instructions for the captain of *The City of Alton*. One can scarcely imagine Mitchell's surprise upon being told to be at the St. Louis riverfront at 11:00 p.m. to receive an arms shipment from the arsenal.

The Civil War

Stokes had gained entry to the arsenal by deception. If the arms were to be loaded onto the steamer, more chicanery was necessary. After pressing into service every available man both inside and outside the arsenal who was loyal to the Union, Stokes ordered the first of the firearms to be removed and loaded onto another moored boat. The secessionists saw what they thought was their opportunity to hijack those coveted firearms. They seized the guns and made off with them—just as Stokes had hoped!

The wily captain had ordered that the first firearms removed should be some five hundred decrepit flintlock rifles that had last seen service in the Mexican-American War. Time-consuming to load and possessing limited range, flintlock rifles would compose a limited danger in Confederate hands. While the secessionists were running away with these almost useless antiques, the arsenal's defenders began loading the modern, more lethal weapons onto the steamer. A few secessionists had not run off with the flintlock-wielding mob, however, and tried to interfere with the arms removal. Stokes had them arrested and locked up.

Major Franklin B. Moore was one of the Union men who accompanied Mitchell on *The City of Alton*, and he gave an account of the arsenal arms transfer in his autobiography:

> *I had hauled a load of lumber that day for the boat and went to the office to get my ticket. John J. Mitchell was there and beckoned me. He said to me in a low tone: "We are going down to the St. Louis arsenal to-night to get the arms stored there. Don't you want to go along?" I answered "Yes." I was told to keep mum, take my team home and return to the boat at night. I carried this out all right. Many of Alton's best men were with us. J.J. Mitchell, Col. S.A. Buckmaster, James Powrie and others I do not recall. We went down to the arsenal and captured the watchmen. No soldiers were within. The remainder of us stayed on the boat. They returned and told us to come on. We were told where we could find the ordnance. We carried for several hours and loaded the boat with muskets, cannon and ammunition. We returned to Alton about daylight next morning. The cargo was loaded on cars by citizens who gathered at the landing, and sent to Springfield.*

Moore's account omits any reference to the flintlocks taken by the secessionists. His statement that no soldiers were within the arsenal is curious, since its precludes the presence of Lyons, Stokes and even the telegraph operator. Still, it's valuable as a firsthand narrative of this event.

Transferring the arms to *The City of Alton* had been a relatively smooth operation. Now, however, the vessel was menaced by the Rebel battery on the levee. According to one old account, Stokes and Mitchell held this terse conversation:

> *"Which way?" asked Mitchell when the steamer was loaded.*
> *"Straight in the channel to Alton," replied Stokes.*
> *"What if we are attacked?" Mitchell inquired.*
> *"Then we'll fight."*
> *"What if we are overpowered?"*
> *"Run her to the deepest water and sink her."*
> *"I'll do it," Mitchell said.*

As fate would have it, however, no such sacrifice was required. *The City of Alton* steamed past the secessionist battery without a single shot being fired.

Upon arriving at the Alton dock about 5:00 a.m. on April 25, Stokes was met by Plummer. The two then ran to the engine house and rang the fire bell. Hundreds of people rushed from their dwellings, some only half dressed, to discover the cause of the alarm. Stokes addressed the crowd: "There is no fire, but at the landing is that steamboat you all know loaded with arms we are getting from the arsenal at St. Louis, to Springfield, and we are afraid the secessionists from St. Louis will follow us and be on us before we get them unloaded. We want everyone to help us."

Men, women and even children readily responded to Stokes's plea for volunteers. By 7:00 a.m., the contents of *The City of Alton* had been loaded and safely locked into the cars of the Chicago and Alton Railroad. Stokes had succeeded in removing 10,000 muskets, 100 new rifles, 500 revolvers, 110,000 musket cartridges and a quantity of cannon from the St. Louis arsenal—all of which would now be used to arm Union volunteers in Springfield.

When Plummer died in 1913 in Portland, Oregon, his funeral oration was delivered by the Reverend C.S. Cline, a Union veteran who personally benefitted from Plummer's role in securing the firearms. Cline noted:

> *That night's work decided the destiny of the Government arsenal, the City of St. Louis and the state of Missouri, and one of the men whose intelligence and capabilities contributed to that national result was the young telegraph operator at Alton—O.P.S. Plummer.*
>
> *Two days after the events just described, the Seventh Illinois Volunteer Infantry, to which I belonged, dropped down from Springfield, going into*

camp at Alton, where we were visited by Mr. Plummer, an aristocratic, dressy looking fellow, with a characteristic grin on his face, as he shook hands with all of us around. The regiment gave three rousing cheers to the operator who helped us secure the arms we carried and which we later used at Fort Henry, Fort Donelson, Shiloh and Vicksburg.

Plummer's role in the St. Louis arsenal episode did not go unnoticed by Washington. He was transferred to Cairo, where the Ohio River joins the Mississippi—a vital point of operations in the western theater of the Civil War. Cairo also served as the terminus of the Illinois Central Railroad, further enhancing its importance to the Union. As a telegraph operator whose loyalty to the Union was beyond question, Plummer was entrusted with the transmission of sensitive, crucially important information.

Stokes's brilliant execution of the arms transfer was merely the first of his military successes during the Civil War. He became commander of the Board of Trade Battery, also known as Captain Stokes's Battery, which was organized in Chicago on July 31, 1862. This battery served with distinction in 1863 during the Union's military campaign in mid-Tennessee. On August 22, 1864, Stokes was appointed captain and assistant adjunct general of the U.S. Volunteers and promoted to brigadier general on July 20, 1865. He was mustered out at that rank on August 24, 1865. He died in New York City in 1890 at age seventy-seven.

The townspeople of Alton who so willingly gave their time and labor to carry that arms shipment from *The City of Alton* to the waiting train took pride in their contribution to the Union cause. They had helped arm their fellow Illinoisans for combat in the Civil War, as well as seriously weakened the Rebel cause in Missouri—perhaps even helping to keep that state from joining the Confederacy. While there were no Civil War battles fought in southwestern Illinois, the men, women and children who responded to that fire bell on the morning of April 25, 1861, won a tremendous and strategically important victory for the Union.

Alton's Turner Hall

A Union Bastion

Its location, on the corner of East Fourth and Ridge Streets in the Hunterstown district of Alton, ensures that it is seen by few tourists. No plaque or marker identifies the building or gives a clue regarding its historical significance. Yet Turner Hall formerly played a vital role in Alton. More importantly, however, it was part of a national movement that figured prominently in our nation's cultural life and even tipped the scales toward the Union side during the Civil War.

The Turner Halls that formerly could be found in so many American cities and towns had their origins in Germany. Friedrich Ludwig Jahn, a patriot and educator, felt that his nation had been defeated by Napoleon's army because his countrymen had not been physically fit. A program of vigorous physical education would produce a hardier German who could defend his nation from invaders, he reasoned. While teaching at a boys' school in Berlin, Jahn introduced new exercises and gymnastic equipment, such as the horizontal bar, vaulting horse, balance beam and parallel bars. In 1811, he began mass open-air exercises in the first *Turnplatz*, or outdoor gymnasium. Jahn's message regarding the importance of physical fitness found a favorable reception with his fellow Germans, and *Turnverein* was born. *Turnverein* is a combination of two German words: *turnen*, which means to practice gymnastics, and *verein*, which means club.

The *Turnvereine* (plural of *Turnverein*) became increasingly political during the ensuing decades. Many members who were passionate liberals devoted as much time to organizing political lectures as they spent practicing gymnastics.

The wave of unsuccessful revolutions that swept Europe in 1848 impacted Germany, a loose confederation of states at that time. *Turnvereine* members participated in these uprisings in the hope of establishing liberal regimes.

When the rebellions failed, a large number of Germans, known as "Forty-Eighters" after the year of the revolt, fled to the United States and brought *Turnvereine* with them. These gymnastic associations soon took root in American communities. English-speaking Americans who found *Turnverein* difficult to remember or pronounce Anglicized the term to Turner or Turner Hall.

American Turners always included gymnasiums to carry on the old *Turnverein* tradition of physical fitness but also functioned as assimilation centers for German immigrants. Turners offered classes in the English language and American history. Conversely, a Turner allowed these immigrants to remain in touch with their German roots. Their native tongue was spoken within its walls, and most *Turnvereine* had large libraries of German-language books. Virtually all *Turnvereine* sported rathskellers—beer halls—where these immigrants could enjoy Germany's favorite beverage.

Some Turners also contained secret armories. These stockpiles of weapons were meant to ensure that German Americans would have the means to defend themselves if they were assaulted by members of the Know-Nothing Party and other native-born bigots who resented immigrants.

Turner Hall is located on Ridge Street in the Hunterstown district of Alton. Many German Americans who belonged to *Turnvereine* enlisted in the Union army.

The Civil War

A large number of German immigrants settled in Alton, which soon had a flourishing Deutsche community. German-owned businesses such as Luer Packing, Dietche's Grocery and Flachenecker's Apothecary thrived in the Ridge Street district of Hunterstown. Alton's Germans chose Hunterstown as their place of business but favored the Middletown area for their churches. Roman Catholics worshiped at St. Mary's, located at the corner of Henry and East Fourth Streets, while German Methodists and Evangelicals kept the Sabbath at churches located at, respectively, Henry and East Seventh Streets and Henry and East Eighth Streets.

The Alton *Turnverein* was founded in 1855 and gave rise to several other local organizations for Germans such as the Froshin Society, a singing group, and the German Benevolent Society. The White Hussars, another Alton *Turnverein*-based organization, eventually became the Alton Municipal Band, which is now recognized as one of the oldest municipal bands in the United States. When the Civil War began in 1861, however, the Alton *Turnverein* proved that its members were passionate about more than just music.

Perhaps more than any other ethnic group, German Americans were adamantly opposed to slavery. *Turnvereine* across the country served as recruitment centers where German Americans readily pledged to preserve the Union and destroy the hated peculiar institution. Those hidden arsenals in many Turners helped to arm early Union regiments.

German support for the North played a crucial role in the Union triumph. Entire companies of Federal troops were recruited from *Turnvereine*. In cities with large German populations such as New York, Cincinnati and St. Louis, *Turnvereine* members composed entire regiments. The St. Louis *Turnvereine* pledged themselves to sacrifice their lives to keep St. Louis city and county in the Union if Missouri joined the Confederacy.

Washington was riddled with secessionists and Confederate sympathizers. The two *Turnvereine* of our nation's capital organized a company of sharpshooters and offered their support to Union forces in the city's defense. The Washington *Turnvereine* also helped to protect Lincoln upon the new president's arrival in Washington and formed part of his bodyguard during the inaugural ceremony.

The Jaeger, an Alton-based military unit, was formed in the 1850s. Virtually all of its members were German Americans who belonged to Alton's *Turnverein*. It is believed that the Jaeger took its name from the German word *Jager*, which means hunter. The Alton Jaeger gained regional renown for its precision drilling and occasionally treated the public to a parade. On October 2, 1855, the Jaeger entertained about one thousand

people when it held a dress parade on the streets of Edwardsville. The event was capped by a grand military ball held at that city's Arcade Hall. At the time, the Jaeger company was commanded by Captain George H. Weigler. In an article commemorating the parade and ball fifty-three years later, the *Alton Evening Telegraph* noted that Wiegler, "although nearly to the century mark in years, is still conducting his drug store in 'Hunterstown,' where he has been engaged in business for many years."

The Jaegers, as the men of this company were popularly called, left Alton for Springfield in April 1861 for service in the Civil War. The *Telegraph* account stated that "an immense and enthusiastic crowd" gathered at the depot to bid the Jaegers farewell. Dr. F. Humbert delivered a spirited address to the Jaegers in German, a language the reporter admitted he didn't know and therefore "cannot speak of the merits of his [Humbert's] remarks."

Throwing aside any pretense of impartiality, the reporter opined, "The Jaegers will be one of the best looking and most efficient companies furnished by Illinois during the campaign." Speaking on behalf of "our city, and state and common country," this unnamed journalist then thanked the Jaegers "for their devotion to the Stars and Stripes." He concluded this tribute by asserting, "We are willing to trust the Alton Jaegers in any position in which they may be placed."

This April 1861 newspaper article listed officers of the Alton Jaeger as John H. Kuhn, captain; H. Schweizer, first lieutenant; J. Schmidt, second lieutenant; and J. Tonsor, third lieutenant. A *Telegraph* article published a month later listed Kuhn as captain and Schweizer as first lieutenant but named E. Adam as second lieutenant and did not list a third lieutenant. Both accounts note four orderly sergeants, four corporals and two musicians. The May article lists the names of sixty-four privates.

While pulling out all the stops to praise the Jaegers, the reporter somehow neglected to cite Alton's *Turnverein* for its role in the creation of this crack military unit, as well as the ideology that guided it. We may safely assume that slavery and secession were frequently and vigorously condemned during many a discussion held at Turner Hall. The participation of the Jaegers in the Civil War proves that the men of the *Turnverein* possessed the courage to support their convictions, even if it meant risking their lives in combat.

The Federal Military Prison in Alton

On William Street in Alton, visitors can see a few limestone blocks arranged in a ninety-degree angle. Three openings in the structure suggest windows or, perhaps, the extremely narrow doorways of small cells. These blocks are all that remain of a prison that incarcerated Confederate prisoners of war during the Civil War.

This military prison opened in 1833 as the first state prison in Illinois. It initially contained just twenty-four cells, but additional cells and buildings were added over the years as the inmate population grew. At its zenith, the prison bordered present-day West Fourth Street on the north, William Street on the east, Broadway on the south and Mill Street on the west.

By the 1850s, however, the prison had become infamous as a disease-ridden pesthouse. The noted penal reformer Dorothea Dix condemned the place and demanded it be closed. A new prison began operating in Joliet in 1859, and the inmates were gradually transferred to that facility. By 1860, the Alton prison was empty.

But overcrowding at the Gratiot Street and Myrtle Street prisons in St. Louis, which housed Confederates who had been taken prisoner as well as civilians guilty of aiding the Rebel cause, forced the Union command to reopen the Alton facility. The first Confederate prisoners arrived on February 9, 1862. Records indicate that at least 11,764 prisoners were incarcerated in the prison during the course of the war. This number includes four distinct categories of inmates: Confederate soldiers; Union troops who had been court-martialed for misconduct; civilians who were Confederate

sympathizers; and bushwhackers, the popular term for guerrillas who fought as Confederate partisans but didn't belong to actual military units.

Several units of Union troops were assigned to guard the prison during the course of the war, including the 144th Illinois Infantry, which was composed almost entirely of area residents and served only in the Alton–St. Louis region. By far, the most unique unit to serve as guards was the 37th Iowa Volunteer Infantry, whose members were the fathers and grandfathers of Iowa volunteers. This unit was popularly known as the Greybeard Regiment, since the average age of its men was about fifty.

Southwestern Illinois copperheads—Northerners who opposed the war and wanted a negotiated peace with the South—fantasized about assaulting the prison to liberate its inmates. Shortly after reopening, however, the Alton prison suffered an attack by a scourge as menacing as any enemy force. A prisoner named Henry Farmer, who was infected with smallpox, arrived at the prison on October 15, 1862. Exacerbated by overcrowding, lack of medical facilities and poor sanitation, the disease spread quickly among inmates and prison personnel alike. Smallpox victims were initially buried in a pasture, which was located on what is now Rozier Street in North Alton. The pasture had been used as a burial ground for inmates who died while incarcerated in the Alton facility when it was the state prison. But when some townspeople fell victim to the disease, the citizens of Alton demanded that the inmate dead be buried elsewhere. They also called for the ailing prisoners' removal from the city's boundaries.

An isolation hospital for those afflicted with smallpox was established on August 21, 1863, on a small island in the Mississippi. Those who succumbed to the disease were buried on the island. This island is still known by several names in southwestern Illinois. Jann Cox, in her brilliant study of the prison and its Civil War dead, referred to it as the Tow Head. It has also been called Sunflower Island, McPike's Island and Mosquito Island. Its best-known—and most chilling—name is Smallpox Island.

Many area residents sometimes confused Smallpox Island with the much-larger Ellis Island, which was located nearby. The problem stems from the fact that Smallpox Island began rapidly silting in about 1930. As the separation between the two became hardly noticeable, some river maps began referring to the Smallpox Island/Ellis Island area simply as Ellis Island.

Those residents who began insisting that Ellis Island was indeed the notorious Smallpox Island of Civil War fame, while mistaken, were inadvertently correct in one respect. The isolation hospital was for a short time indeed located on Ellis Island. In early 1865, with the epidemic still

raging, Smallpox Island was flooded by the rising river. The isolation hospital was hurriedly moved to Ellis Island. It is doubtful whether any of the dead were interred on Ellis Island, however.

Two other important misconceptions that arose about Smallpox Island during the years following the Civil War concern the number of inmates buried at the site and the notion that removal to the island was tantamount to a death sentence. Local lore insisted that thousands perished in the isolation hospital and that no one returned alive from Smallpox Island. Removal to Smallpox Island, storytellers claimed, came to be known among the prisoners as a "living burial."

U.S. government records indicate that 263 prisoners died while patients at the military hospital. Of that number, 247 were Confederate officers, enlisted men and conscripts, while the remaining 16 were civilians. While 263 deaths are indeed tragic, it is a far cry from the supposed thousands who were alleged to have perished on Smallpox Island. But what of the claim that removal to the island hospital was a living burial?

Again, the facts are considerably less grim than the myth. Prisoners not only survived removal to Smallpox Island but even used it as an opportunity to escape from custody. The island was just one thousand feet in diameter and separated from the Missouri mainland by nine hundred feet of slough that was normally less than twelve feet deep. For example, records show that on March 31, 1864, one Captain Albert W. Cushman, First Tennessee Cavalry, who had been captured in Tennessee just sixteen days before, escaped from the isolation hospital with a Private Hiram T. Wethers of Company D of the Tenth Missouri.

Cox found reports that indicated about sixty prisoners who died from diseases other than smallpox were buried somewhere on the Missouri mainland itself. Southwestern Illinois lore has long claimed that some inmates were interred on Show-Me State soil, although there is no consensus as to the location. These graves, if indeed they exist, remain undiscovered.

Griffin Frost

Confederate Prisoner of War

Born in the free state of Ohio in 1834, Griffin Frost became a southerner while still a boy when his family moved to Virginia. He entered the field of newspaper publishing and worked at a number of periodicals. He moved to Missouri in 1854 and began a newspaper in Palmyra. He married the daughter of a slaveholder in 1857 and fathered a daughter, his only child. Along with his brothers, Frost published a newspaper in Mexico, Missouri, and later founded the *Shelby County News*.

Like many Missourians, Frost favored secession as the nation began to split asunder. When Fort Sumter was bombarded, Frost's newspaper proclaimed its support for the Confederacy. But the Show-Me State had its share of anti-secessionists as well. A contingent of the Home Guard, which supported the Union, paid Frost an unfriendly visit in June 1861 and demanded that he halt publication of his newspaper. Although Frost complied, his newspaper office was vandalized a short time later and its press destroyed. An angry Frost threw in with the Confederacy and joined the Missouri State Guard. His brother John Frost also fought for the South and, like his brother, became a prisoner of war who was incarcerated in Alton. Another brother, Daniel Frost, stood with the Union and served as colonel of the Eleventh West Virginia Infantry. Daniel was shot in the bowels at the Battle of Snicker's Gap on July 18, 1864, and died two days later. Griffin learned of his brother's death while a prisoner at Alton.

Griffin Frost saw action in Missouri, Mississippi and Arkansas before being captured in Carroll County by a pro-Union Arkansas cavalry regiment on

November 8, 1862. He was among about one hundred prisoners who arrived at the Gratiot Prison in St. Louis on New Year's Eve 1862.

The former editor was paroled on April 22, 1863. He soon rejoined Confederate forces, only to be recaptured by the pro-Union Missouri State Militia in October of that year. Upon his transfer back to Gratiot, Frost refused to obtain his freedom by taking an oath of allegiance to the Union. On January 30, 1864, he was transported to the Alton prison.

Frost's journal begins with an entry dated August 1, 1861, and records his experiences on the battlefield and also as a prisoner of war. We shall concern ourselves with that portion of his journal that records his experiences in Alton. Frost smuggled his journal into the Alton prison by wrapping it in an old shirt. His entry for January 31, 1864, notes that thirty-two inmates occupied a room "eighteen feet square; some have bunks, others take the floor." Twenty-four hours later, he decided that Alton "is a much harder place than Gratiot—it is almost impossible to sleep on account of the rats, which run over us all through the night; it is hard to tell which are thickest—rats or men." Frost also wrote that many of the inmates were sick, and deaths were a daily occurrence.

Griffin Frost, a newspaper publisher, served with the pro-Confederate Missouri State Guard. As a prisoner of war, he was incarcerated in the Alton prison. *Courtesy of the State Historical Society of Missouri.*

His journal entry for February 3 recorded two escape attempts. Ten or twelve men attempted to dig a tunnel from one of the prison's outer buildings but were overheard by a sentry. These prisoners were punished by confinement to cells for an indeterminate amount of time. The second attempted escape bordered on the farcical. Two Rebels feigned death and were consigned to coffins. When a Union sergeant opened one of the coffins to recover a pair of hospital socks, the "corpse" sat up and asked what he wanted. The sergeant, convinced that a dead man had returned to life, fled in terror. This Rebel paid dearly for the sergeant's quest for socks. The Union brass ordered him to be sealed in a coffin

The Civil War

These lice combs were carved from bone by Private Silas H. Higley, Company H of the Eighth Missouri, while he was a POW at the Alton prison. *Courtesy of Nancy Alexander.*

and buried alive. After allowing the Confederate to fret inside the coffin for a while, he was released and ordered to abandon any further attempts at escape.

Frost spent a little over two weeks in February at the prison hospital for a throat infection. He described hospital food as poor-quality baker's bread or half-baked corn bread, coffee and a bit of diluted milk for the very ill. Death was the prisoners' constant companion. "It not unfrequently happens that a man dies in his solitary bunk and the fact is not discovered for several hours, and when it is found out, no one looks astonished or seems to care. The corpse is carried out like so much rubbish, thrown into a rough box, and literally tossed into a shallow grave."

Frost was returned to Gratiot in early March and then sent back to Alton eight months later. He reported that this Illinois prison had been improved a great deal since his previous incarceration. "Everything is much cleaner; a large hospital has been built, lathed and plastered, and lit with gas, and the authorities, I am told, manifest a greater degree of humanity."

His breakfast, we are informed, was "hearty" and consisted of biscuit, beefsteak and coffee. The inmates, when not breaking rocks, passed time by making "tooth picks, rings, breast pins, and such like, and many of them were executed with a great deal of skill." Prisoners also played cards to wile away the hours.

Interaction between male and female inmates was permitted and undoubtedly made prison life more tolerable. When Confederate soldiers visited the women's quarters, "an evening never passed more pleasantly than in the enjoyment of their society," according to Frost. Those Confederates with pleasant singing voices "visited the windows of our lady prisoners and entertained them for some time with a serenade."

Still, Frost's journal reveals that punishment for infractions of prison regulations was severe indeed. "Saw a prisoner tied up by his thumbs to-day,"

he wrote on October 7. The inmate was left in this torturous position for a half hour to one hour at a time. A day earlier, Frost had recorded the "bucked and gagged" penalty meted out to an escaped prisoner named Westerman who was apprehended. "He was made to sit on the ground with his legs drawn up, and a crow bar placed under his knees and over his arms, while his wrists were bound with strong cords in front. Then a stick, eight or ten inches in length, with a string at each end, placed in his mouth and tied behind his head."

Early December 1864 was particularly horrendous at the prison. Frost's entry for the eleventh notes that there were thirteen deaths in the hospital the previous night, and a man in another building was found frozen to death in his bunk. The hospital was so crowded that "it is impossible for a sick man to gain admittance; when one goes in, the doctor tells him to 'take a seat, there is no room now, but some fellow will die in a few minutes, and you can take his place.'" The journal entry for December 13 has twelve more men dying in the hospital during the previous twenty-four hours, although Frost concedes that the actual number could have been even higher.

The mercurial nature of prison life is reflected in Frost's description of a Christmas dinner he and several other inmates enjoyed with Captain Edward Muir, a fellow prisoner of war. The main course—roasted goose—was undoubtedly a fare far superior to the Christmas meal that was eaten by most soldiers, Union or Confederate, in the field. Frost enjoyed a genuine feast the next day when he and other male inmates dined with some female prisoners. The featured meats included goose, beef, duck, turkey, chicken and bacon. In addition to several side dishes, there were even two desserts: mince pie and cranberry tart. This 4:30 p.m. meal was followed by a light supper at 8:00 p.m. that was composed of coffee, tea, fruitcake, jelly cake and pound cake. These pleasant journal entries for December 25–26, 1864 contrast starkly with that month's earlier description of rampant suffering and death among the inmates.

The April 5, 1865 entry notes that "Monday was the gloomiest day we have spent in prison" because "the telegraph reported the fall of Richmond and Petersburg." Local Unionists rejoiced, and "Federal flags were waving everywhere." Frost notes that this news was confirmed the following day. "Our beloved land," he mourns, "has fallen prey to the wiles of wicked men." Frost's gloom was surely alleviated by learning on April 11 that he "was released by order of President Lincoln." At 5:00 p.m. that evening, he was aboard the steamer *Warsaw* and bound for Hannibal, Missouri. From there, he journeyed by horse and buggy to Palmyra, where he arrived at the home of his father-in-law. "I found my wife and baby in the enjoyment of excellent health."

Mary Ann Pitman

The Cross-Dressing Spy

Barbara Ann Dunevan was an impoverished, illiterate resident of Tennessee who was court-martialed for smuggling revolvers to the Confederate army. She was sent to the Alton prison, where she contracted smallpox during the epidemic that swept through that institution. Dunevan was banished to the isolation hospital, where she died on September 28, 1863. She was buried on Smallpox Island. Since Dunevan's gender was unmistakable, she was incarcerated in the Alton prison as a woman and under her true name. Another female inmate, however, went by two aliases during her incarceration—one female and one male!

May Ann Pitman of Chestnut Bluff, Tennessee, believed so strongly in the cause of Southern independence that she disguised herself as a man and recruited a full cavalry company for active service. Using the alias Rawley, she was commissioned a second lieutenant. Pitman and her company participated in the Battle of Shiloh, where she was wounded in the side. Later, she was assigned to the command of Confederate general Nathan Bedford Forrest, to whom she revealed her true identity and gender. Pitman asked Forrest whether he wanted her to resign. Recognizing her potential usefulness, he replied no. "Rawley" was promoted to first lieutenant and ordered to spy and smuggle firearms for the Confederacy.

Pitman decided that she could more easily move behind Union lines as a woman. She discarded her identity as Lieutenant Rawley and became "Molly Hayes," a charming loyal Unionist who successfully lured information regarding fortifications and troop movements from gullible young officers.

Pitman also excelled in acquiring firearms and other supplies in St. Louis and transporting them to the Confederates.

Pitman's career as a spy and smuggler came to an abrupt end in the spring of 1864, when she was apprehended by Union forces near Fort Pillow, Tennessee. Fearful of execution by Federal authorities, she eagerly cooperated with her captors and offered to reveal her undercover contacts and everything she knew about Confederate troop movements. Pitman was transported to St. Louis for interrogation by Colonel J.P. Sanderson, provost marshal general of the Department of the Missouri.

While in St. Louis, Pitman was contacted by a Confederate colonel who gave her a letter from Forrest that urged her to return to the Confederate army. She asked the colonel to tell Forrest that she was doing more for the Confederate cause in St. Louis than she could possibly accomplish with his army. While meeting with the colonel, she learned about an upcoming Confederate raid in Missouri and later turned over this information to Sanderson.

Union officials decided to use Pitman as a double agent. She was jailed at the St. Charles Street Prison for Women, where she was apprehended after a staged "escape." This scenario was designed by Pitman's Union handlers to make it appear that she was still a loyal Confederate who had been trying to return to Rebel forces. Pitman's first assignment as a double agent was to infiltrate the headquarters of Confederate general Sterling Price, although it isn't clear whether she was able to accomplish this objective.

Pitman was then sent to the Alton prison about November 1, 1864, in her undercover persona of Confederate sympathizer. Griffin Frost, in his prison journal entry for November 3, wrote: "A female, dressed in male attire, and calling herself Mollie [sic] Hayes, was brought in night before last—she is said to be a very hard case."

Prison officials assigned Pitman the job of assistant letter inspector. Whether she was performing espionage work at Alton's prison or was sent there merely to bolster her cover as a captive Confederate is uncertain. It has been established, however, that Pitman used two aliases while in Alton: Molly Hayes and Charles Thompson. Perhaps some inmates and prison staff knew her as a woman, while a quick change of clothes enabled Pitman to pass herself off to others as a man. She was now a far cry from the beguiling spy who had coaxed sensitive military information from young Union officers. Frost's journal entry for November 15 reads: "Last Saturday I saw the *female man* (Mollie Hayes) for the first time, as she was on her way to dinner. She was still arrayed in masculine attire. Her features are coarse, face round

and full, a turn up nose, hands and feet small. She has a rather masculine appearance, and is by no means a pleasing object to look upon."

She was still incarcerated in the Alton prison when President Abraham Lincoln granted her a full pardon on November 24, 1864. She was formally released five days later.

Pitman became as committed to the North as she had once been to the South and served the Union alternately as a man or woman. Assuming her old identities of Lieutenant Rawley and Molly Hayes, Pitman scoured Missouri for Rebel sympathizers who agreed to sell her firearms and supplies for the Confederate army. She then turned their names over to Union officials for arrest and prosecution.

When the war ended, Pitman was paid $5,000—the equivalent of about $70,000 today—by the United States War Department for her service to the Union. She then vanished and was never seen or heard from again. Perhaps she feared retribution from her former Confederate comrades and adopted yet another alias for the rest of her life. We can only wonder whether this new identity was that of a man or woman.

The Confederate Underground

The Illinois elections of 1862 were disastrous for Unionists. A majority of the new legislators opposed the war and wanted a negotiated peace with the South. Alton Unionists responded to this threat by holding a mass meeting in February 1863 that passed a resolution supporting vigorous prosecution of the war until all armed resistance to the Union had been defeated. Another resolution avowed support for the Emancipation Proclamation, which had gone into effect the previous month. These Unionists proclaimed that they approved of the proclamation and pledged "to defend and maintain it against its northern defamers."

Despite Alton's show of support for the Union, Confederate sympathizers were not lacking in southwestern Illinois. Families from Southern and border states that had settled in the area still felt a strong kinship with Dixie and supported its war for independence. Other southwestern Illinoisans saw the Civil War as being waged not to preserve the Union but to free the slaves—a goal they regarded as senseless and repugnant.

Copperheads organized secret societies such as the Knights of the Golden Circle, which was later renamed the Sons of Liberty. A chapter of this society existed in southwestern Illinois and included such dignitaries as James Semple, a former senator and the founder of the village of Elsah in Jersey County; John Dobelbower, editor of the *Alton Democrat* and publisher of the *Jerseyville Democratic Union*; and former Alton mayor Thomas Hope, who often boasted that he fired one of the fatal shots that had killed Elijah Lovejoy.

Dobelbower was particularly strident in expressing his hatred for the Union. When antiwar Democrats captured the Illinois legislature in 1862, the *Jerseyville Democratic Union* proclaimed, "Jeff Davis King of Little Jersey!" and "The Stars and Stripes Prostrate!" During the presidential race of 1864, this same newspaper predicted Lincoln's defeat and stated that "Washington has been so long DESECRATED BY THE HIDEOUS PRESENCE OF THAT TRAITOROUS DEMAGOGUE AND UPSTART TYRANT." Hope later testified that Dobelbower "strenuously advocated a revolution, and was for the burning of dwellings, barns, fences and property of Union men of the North."

Local Southern partisans saw themselves as a Confederate vanguard who would prepare the region for the invasion of a Rebel army from Missouri. Like many copperhead extremists, they wanted to free Confederate prisoners who were held in the North and forge them into a Rebel army that would wage war behind Union lines. The Alton prison ranked high on the list of regional copperhead targets, but an assault was never attempted.

A band of pro-Confederate guerrillas known as Henderson's Army posed the most serious threat to the Union and its supporters in southwestern Illinois. William Henderson, who had served in General Sterling Price's army in Missouri, escaped from the Alton prison and made his way to Carrollton in Greene County and allied himself with a Captain Carlin, who supported the South. These two began recruiting Confederate sympathizers for an infantry unit. Drills were held every Saturday and Sunday in open glades along Piasa Creek in Jersey County.

Some of the rambunctious young recruits soon tired of infantry drills, however, and decided they wanted to be a cavalry unit. Henderson, an infantryman, opposed the idea, but Carlin, an expert horseman himself, approved. A southwestern Illinois bushwhacker cavalry was born.

Henderson's Army, led by its namesake and Carlin, left a trail of robbery and murder across southwestern Illinois. The *Alton Telegraph* denounced Henderson, Carlin and their comrades as "murderers, horse thieves and desperadoes" who "were known as reckless, ruthless members of the Knights of the Golden Circle, and sympathizers with Jeff Davis and the rebellion."

In November 1864, Henderson and two gang members were drinking at the saloon of a Dr. Jay in the town of Fidelity in Jersey County. Jay, a leader of the Knights of the Golden Circle, suggested that they kill two Union soldiers who were home on furlough. The gang complied by murdering the soldiers in a Fidelity store.

The Civil War

Henderson remained on his mount and held the reins of his companions' horses while they killed the soldiers. This made him a ready target for George Miller, the manager of another local store, who rushed outside with a double-barrel shotgun. Henderson and Miller fired at each other simultaneously. The store manager fell dead, while Henderson caught buckshot in his right leg.

A posse apprehended Henderson in a Macoupin County farmhouse, where he had sought medical care for his wound. He was being returned to Fidelity by this posse when he was shot to death under circumstances that were never explained. Henderson was buried near the village of Medora. One of the two Union soldiers' murderers was captured, tried and hanged. The other, according to an old account, "now lives in Missouri, and is known as a reformed, law-abiding citizen." Deprived of its leader, Henderson's Army gradually dissolved, and peace returned to southwestern Illinois.

The Thirteenth Amendment

U.S. senator Lyman Trumbull was one of several politicians who witnessed the Battle of Bull Run in 1861, which was a disastrous rout for the Union. The experience goaded him into becoming a staunch critic of the incompetent leadership that plagued the early Union forces.

When Congress passed a bill that authorized the confiscation of property used for insurrection, Trumbull added an amendment that offered freedom to slaves whose masters forced them to take up arms against the Union. Lincoln chose not to enforce the Confiscation Bill because he didn't want to antagonize the slaveholding border states that had remained loyal to the Union. Still, Trumbull was proud of the measure since it represented one of the first steps toward emancipation. He later sponsored an even stronger Confiscation Bill that declared freedom for the slaves of those in rebellion against the Union and ensured that Federal forces were no longer required to return runaway slaves to their Rebel masters.

Trumbull's respect for the law induced him to oppose Lincoln's policy of arresting dissidents who supported the South and wished to see it triumph. While the Illinois senator also wanted such traitors to the Union jailed, he maintained that Congress must duly authorize such emergency detentions. Congress, not the president, had the right to suspend habeas corpus, Trumbull argued. His bill, which Congress passed in 1863, allowed the commanding general as well as the commanders of military departments to suspend habeas corpus and authorized military tribunals to try persons charged with treason.

As chairman of the Senate's judiciary committee in 1864, Trumbull proposed a constitutional amendment to outlaw slavery in the United States. Slavery, he argued to the Senate, was ultimately the cause of secession and the Civil War. Lincoln's Emancipation Proclamation in 1863 had declared that all slaves in the secessionist states were free, but what of those slaves not living in the Confederacy? The only way to end the scourge of slavery conclusively, Trumbull declared, was to pass a constitutional amendment that banned it forever. The Thirty-eighth Congress sent the Thirteenth Amendment to the states for ratification on January 31, 1865. The Illinois legislature, voting along party lines, ratified the amendment on February 1, 1865—the first state in the Union to do so.

Although residents of southwestern Illinois took pride in Trumbull's achievements and closely followed his career, he no longer lived in the area. Trumbull had moved to Chicago in 1863. The railroads had made the Windy City one of the nation's leading cities, which meant that it could offer attorneys such as Trumbull much more legal business than Alton or other southwestern Illinois towns. Besides, Stephen Douglas's death had left Chicago without representation in the U.S. Senate, and that city's politicians might try to replace downstater Trumbull with a native son. Relocating to Chicago, Trumbull reasoned, would preempt such a move.

Part III
Post-Bellum

Alton's Turner Hall

Two years after the Civil War, Alton's *Turnverein* acquired a permanent home with the construction of Turner Hall on the corner of East Fourth and Ridge Streets. The Alton City Directory for 1868–69 stated that the *Turnverein* held its regular business meeting on the first Wednesday of each month. Members met for gymnastic exercises every Monday, Wednesday and Friday evening. Friedrich Ludwig Jahn would have indeed been proud.

The 1874 directory noted the *Turnverein* had "a splendid hall…built of brick and stone, with pleasant grounds surrounding." Its library contained one thousand volumes and a reading room. Turner Hall's property value was listed at $11,000, a sizable sum at the time.

On July 4, 1879, a large number of Turner members boarded the *Spread Eagle* to enjoy an excursion on the mighty Mississippi. Upon returning, they followed a marching band from the foot of Henry Street to Turner Gardens, a small park that adjoined Turner Hall. The Germans then enjoyed an outdoor concert at Turner Gardens, which was illuminated for the first time by gaslights.

Music remained an important part of Turner Hall. Families could take lessons in singing and dancing or even learn to play a musical instrument. Turner members with good voices could join the *Maennerchor*, the official singing group of the *Turnverein*.

German Americans figured prominently in building the American labor movement, and many unions held meetings in Turner Halls. In addition to gatherings devoted to organizing union locals and scrutinizing proposed

contracts with management, Turner Halls also functioned as sites for gala celebrations. Local 21 of the Glassblowers Union held its third annual ball at Alton's Turner Hall in 1881, an event that drew a crowd of more than 350 people garbed in "rich, exquisite dresses and conventional dress coats," according to a newspaper account. The highlight of the evening was a waltz contest, in which 24 couples competed for a gold pin for the gentleman and a "fine gold finger ring handsomely set in stones" for the lady.

Turner Hall entered the twentieth century as one of the pillars of Alton's cultural and business communities. When the East End Improvement Association was founded in 1916 as a civic and business organization, many German Americans joined this new group while remaining *Turnverein* members. The East End Improvement Association worked to get roads paved in that section of Alton and streetlights installed on East Broadway. It also started a beloved tradition in 1916 by organizing an annual Halloween parade. By their participation, *Turnverein* members helped to make possible these critical civic improvements.

Turner Hall remained an integral part of Alton until it was overtaken by the wave of anti-German hysteria that engulfed the United States during World War I. President Woodrow Wilson appointed George Creel to head the Committee on Public Information, a federal agency charged with the task of marshaling public support for the war. Creel evidently decided that the quickest, most efficient means of achieving this goal was to incite an irrational hatred of anything German. History shows that Creel succeeded all too well.

Universities, colleges and high schools banned German language courses from their curriculum. Public performances of musical compositions by Bach, Brahms and Beethoven were forbidden. Streets with German names were abruptly changed. Alton Township supervisor and local historian Don Huber found that Alton's German Street was renamed Victory Street.

Traditional German foods were deemed unpatriotic, so sauerkraut became liberty cabbage. Given its Germanic origin, even the lovable dachshund was suddenly unacceptable and renamed a liberty pup. Since beer was regarded as the traditional beverage of Germany, many Americans decided they shouldn't drink it. Declining sales forced the St. Louis–based brewery giant Anheuser-Busch to slash production.

Modern readers may chuckle at such absurdity, but this anti-German madness made life difficult—even dangerous—for many German Americans. An untold number of American citizens who were recent immigrants to the United States or even native-born residents with Germanic surnames were

physically assaulted by mobs of self-proclaimed patriots who viewed their victims as traitors. This bigotry turned deadly in 1918 when Robert Prager, a German immigrant, was lynched by a mob in the southwestern Illinois town of Collinsville. It took a jury just forty-five minutes to acquit his killers.

In such an atmosphere of unreason, it was hardly prudent to belong to an organization that had originated in Germany and celebrated German culture. *Turnvereine*, whose members had so despised slavery and had rallied to the Union banner during the Civil War, were now seen as subversive organizations. Membership in United States *Turnvereine* plummeted, and Alton's Turner Hall was no exception. World War I ended on November 11, 1918, but prejudice against German Americans lingered. By 1921, Alton's *Turnverein* was a shadow of its former self, and the remaining members decided to merge with the East End Improvement Association.

Alton's Turner Hall became the property of the association, which provided for its upkeep. The popularity of the *Turnverein* in its heyday was underscored in 1924 when a new floor had to be installed. The old floor had been worn thin by decades of dances.

Its glory days were over, but Alton's *Turnverein* still maintained a slight presence in Alton by offering exercise classes at Turner Hall's gymnasium. In 1934, however, the East End Improvement Association leased Turner Hall to the Modern Woodmen of America, a fraternal organization. *Turnverein* classes ceased in December of that year, never to be resumed. Ted Beneze, *Turnverein* gym instructor since 1929, announced in September 1935 that all exercise equipment had been sold to East Alton–Wood River High School. The removal of the equipment "marked the last vestige of the Turnverein and its physical training accessories from Alton," the *Alton Evening Telegraph* reported. An era had ended.

The Nation's Oldest Memorial Day Parade

Southern Illinois native John A. Logan served as a major general in the Union army during the Civil War. On May 5, 1868, in his capacity as national commander of the Union veterans' organization known as the Grand Army of the Republic, Logan issued General Order No. 11. It stated, "The 30th day of May, 1868 is designated for the purpose of strewing with flowers or otherwise decorating the graves of comrades who died in defense of their country during the late rebellion, and whose bodies now lie in almost every city, village and hamlet churchyard in the land." These fallen warriors, Logan continued, "were the reveille of freedom to a race in chains, and their deaths the tattoo of rebellious tyranny in arms." He commanded GAR members "to guard their graves with sacred vigilance."

Since this day was devoted to decorating graves, it was initially known as Decoration Day. Logan's prestige lent impetus to this fledgling tradition, and by 1890—four years after his death—Decoration Day was a legal holiday in all the northern states. After World War I, this holiday became known as Memorial Day and honored slain American military personnel from all wars.

The city of Alton held its first Decoration Day parade in 1868, making it one of the oldest—perhaps even *the* oldest—continuously held Memorial Day parade in the United States. The earliest mention of Decoration Day in Alton's *Telegraph* appears in 1871. Veterans and other area residents held a public meeting to lay plans for the parade and the decorating of graves. This meeting was held at Turner Hall, since that organization had been such a loyal Union stalwart during the Civil War.

Griffin Frost

Newspaper Publisher and Author

Frost and his family moved to Quincy, Illinois, shortly after his release from the Alton prison, where he worked as a typesetter before starting two newspapers in that city. He published *Camp and Prison Journal* in 1867. The book included an appendix that consisted of contributions from other Confederate prisoners of war who detailed their experiences in Union prisons. As a proud Confederate, Frost was obviously angered by public condemnation of the suffering endured by Union inmates at notorious Confederate prisons such as Libby and Andersonville. *Camp and Prison Journal* was meant to be an indictment of Northern prisons that would prove incarcerated Rebels had suffered every bit as much as any jailed Yankee.

While Frost's book is valuable as an account of life in the Alton and Gratiot prisons, it fails in its primary objective. While hardly an ice cream social, both prisons were a far cry from living hells such as Andersonville and Libby. Modern readers find Frost's racism abhorrent. While imprisoned at Gratiot, for example, he rejected switching sides and fighting for the Union by ridiculing the Emancipation Proclamation as "old Abe's proclamation for the liberty of the jay-heeled, wooly headed improved monkey from Africa." Frost's August 7, 1864 journal entry is even more explicit in expressing the racism that lay at the heart of the Confederacy:

> *Four white men were conducted past the* [Gratiot] *prison this evening by a squad of negroes, who looked as if they felt the dignity of their new position. We have often seen negro men, women and children walking the*

Griffin Frost, author of *Camp and Prison Journal*, in a photo taken about 1905. *Courtesy of Camp Pope Publishing.*

streets and when opposite the prison they would turn toward us, making all manners of faces, roll their eyes, stick out their tongues, dance, and appear perfectly delighted at seeing us in prison. We observed it a curious illustration of what that species of monkey can be taught.

This unreconstructed Confederate left Quincy for Edina, Missouri, and acquired the *Knox County Democrat*. Retiring from newspaper publishing in 1905, Frost moved to Siloam Springs, Arkansas, with his wife, daughter, son-in-law and grandson. He died there in 1909, and his body was returned to Edina for burial in that community's Linville Cemetery.

The Political Odyssey of Lyman Trumbull

In 1866, Trumbull introduced two bills as part of the Reconstruction program. One measure renewed the Freedmen's Bureau, which had been created in 1865 as a temporary measure. Trumbull's bill sought to make the bureau a permanent agency and allowed it to hire at least one government agent for every county in the South. The bill was passed by Congress but vetoed by President Andrew Johnson. Congress initially failed to muster the required two-thirds vote to override Johnson's veto. Later, however, both the Senate and the House rallied to pass the measure over Johnson's opposition.

The Civil Rights Act of 1866 was designed to counterbalance the defeated South's attempt to deprive former slaves of their rights as free men and women. Southern states passed Black Codes, which were laws that forbid blacks to own weapons or testify against whites in court. Former slaves were required to carry passes while traveling at night and to yield the sidewalk to any white person. Terrorist organizations such as the Ku Klux Klan and the Knights of the White Camellia were formed to maintain white supremacy in the South.

Trumbull's bill stipulated that every inhabitant of the United States, regardless of race or previous condition of slavery, must be afforded the right to sue, enforce contracts and give evidence in court, as well as inherit, purchase, lease, sell and hold personal and real property. Former slaves could not be subject to discrimination in legal penalties and punishments, despite any state laws to the contrary. The president was duly empowered to employ the army and navy in the enforcement of the bill. The Civil Rights Act of 1866 was also vetoed by Johnson, but Congress was successful in overriding it.

When Johnson was impeached for violating the Tenure of Office Act and brought to trial before the Senate, Trumbull was one of seven Republican senators who refused to vote for conviction. Trumbull believed that Johnson's impeachment was primarily politically motivated. He argued that if such partisanship were allowed free rein, no future president would be secure in office if he differed with Congress over any important issue.

The Republican Party won the presidency in 1868 with the election of Ulysses S. Grant. Trumbull, however, began to distance himself from his party by criticizing its Reconstruction policies. When Georgia unseated the black members of its legislature, Congress passed a bill for the reconstruction of that state. Georgia would have to readmit its black legislators; in addition, all members of the legislature would be required to take a loyalty oath under the Fourteenth Amendment and ratify the Fifteenth Amendment.

Trumbull opposed the bill and advocated a states' rights perspective, arguing that the Constitution actually allowed the citizens of Georgia to bar blacks from public office. He even went so far as to question the veracity of accounts of Ku Klux Klan atrocities committed against blacks in Georgia. Federal intervention in the South was unsuccessful in keeping the peace, he concluded, so the responsibility for maintaining law and order should be given to the states.

Trumbull's relationship with the Senate Republicans became further strained in 1871, when he opposed a bill that would have curbed the Ku Klux Klan's war of terror against blacks by authorizing the suspension of habeas corpus in those sections of the South where state authorities were unable to

U.S. senator Lyman Trumbull wrote the Thirteenth Amendment, as well as the Civil Rights Act of 1866. *Courtesy of the Library of Congress.*

suppress the organization. The measure, which was supported by the Grant administration, also gave the president the right to send federal army and naval units to the South to suppress racist violence.

The Illinois senator announced his opposition to the bill on constitutional grounds. He felt that the U.S. government had been created for national and general purposes and not for the protection of the individual in his personal and property rights. While the federal government certainly had the right to use its power to protect the interests of the United States, Trumbull maintained, it had no authority to enter individual states to protect individual rights. The idealistic lawyer who had fought slavery in Illinois was now willing to turn his back on blacks living in former Confederate states.

He supported a bill to grant amnesty for ex-Confederates and opposed Radical Republican Charles Sumner's attempt to attach to the amnesty bill a civil rights amendment that would have outlawed racial discrimination. By 1872, Trumbull was calling the disenfranchisement of southern whites a tragic mistake. State and municipal governments composed of ex-Confederates would be preferable to the Reconstruction governments, he asserted, since the southern states were ruled by thieves.

Trumbull knew that the end of Reconstruction and removal of federal troops would give white southerners free rein to disenfranchise blacks and rob them of their civil rights. But reconciliation of the North and the South, rather than civil rights for blacks, was now his primary objective. Still, Trumbull supported some progressive causes, such as equal pay for equal work and women's suffrage.

Trumbull broke with the GOP in 1872 to support Horace Greeley, who sought the presidency as the candidate of the Liberal Republican Party as well as the candidate of the Democratic Party. Unlike Grant and the mainstream Republicans, the Liberal Republican Party argued that the goals of Reconstruction had been achieved and federal troops should be withdrawn from the South. The Liberal Republicans also assailed the corruption of the Grant administration and called for extensive reform of the civil service.

Despite these charges, Grant handily won reelection, which effectively destroyed Trumbull's senate career. Now a pariah to the Republicans, Trumbull returned to the Democratic Party. He served as a counsel for Democratic presidential candidate Samuel Tilden in the disputed presidential race of 1876. Four years later, Trumbull ran for governor of Illinois as a Democrat but lost.

Again turning his attention to his law practice, Trumbull befriended and mentored William Jennings Bryan, who became a law clerk in his office and frequent visitor to his home. Trumbull also became acquainted with Clarence Darrow, whose law office was in the same building on Chicago's Monroe Street. Darrow sought and received Trumbull's assistance in defending American Railway Union president Eugene Debs, who had been arrested and jailed for his role in leading the Pullman Strike. Darrow had applied for a writ of habeas corpus, which had been refused. The noted attorney then appealed to the Supreme Court and assigned Trumbull the task of arguing the case. The appeal was denied.

In September 1894, Trumbull accepted Darrow's invitation to address a mass election rally that was sponsored by the People's Party. In his address, Trumbull assailed the concentration of wealth in the hands of a few. Congress and state legislatures should pass laws to curb the power of corporations, and voters should elect representatives of labor to public office, he argued. Ironically, the man who had withdrawn his support from civil rights legislation concluded his speech by urging blacks to support the People's Party. Raising his hand, he exclaimed that it was the hand that had written the nation's Civil Rights Act of 1866.

Trumbull's address was so well received that the Chicago branch of the People's Party asked him to draft a declaration of principles for presentation to a People's Party convention that would be held in December in St. Louis. The first principle of Trumbull's nine-point declaration affirmed that brotherhood and equality of rights are the cardinal principles of true democracy. The declaration concluded with a call for the rights of the masses to take priority over millionaires and monopolies. All nine points were adopted without dispute at the St. Louis convention.

Lyman Trumbull died in Chicago on June 25, 1896, and was buried in that city's Oakwood Cemetery. While his abandonment of civil rights advocacy in the later years of his Senate career undoubtedly mars his legacy, Lyman Trumbull's role in ending slavery in Illinois and the United States more than secures his place in the pantheon of liberty.

Thaddeus Hurlbut

The Years of Disappointment

Thaddeus and Abigail Hurlbut were shattered by their son's death but felt that the Union victory, with its final destruction of slavery in the United States, meant that he had not died in vain. Hurlbut was recognized as a pillar of Upper Alton and accepted an appointment as postmaster of the city during the 1860s.

The post–Civil War years were a keen disappointment for abolitionists. Ex-Confederate soldiers and southern politicians founded the Ku Klux Klan in 1865 to wage a war of terrorism against former slaves. When Reconstruction ended in 1877, the southern states established white supremacist governments that disenfranchised African Americans and forced them into second-class citizenship.

While these aged abolitionists knew that African Americans were suffering oppression, they didn't possess the strength to launch a new crusade. Thaddeus Hurlbut was no exception. He spent the postwar years writing and serving interim pastorates. Not only had this minister spent most of his adult life in the abolitionist movement, but he had also lost his only son on a Civil War battlefield. It was time for a new generation to take up the struggle for human rights.

Even in his old age, Hurlbut remained inexorably linked with Lovejoy in the minds of many area residents. He received a letter from W.C. Quigley, an Alton resident who owned Quigley and Company, Wholesale Druggists, dated November 7, 1880, that read:

This monument to Wilberforce Lovejoy Hurlbut is located in Alton's City Cemetery. The young warrior went missing in action during the Battle of the Wilderness, and his body was never recovered.

Dear Sir:

Do you look back, on the long years that have passed over your head in Alton, Do you remember where you were forty three years ago this night? I had prior to that night seen you—on the street and in the Pulpit. I have met you occasionally ever since. But the meeting on that night seems to have obliterated all other recollections of you, when your name is mentioned I only remember you as I saw you then.

After the Murder of Mr. Lovejoy, the destruction of his Press, the flight of his friends and the defenders of his property, I, a boy a mere "looker on the Vienna" approached the office door in company with several men, when we paused, feeling ourselves in the Presence of the Dead, you came out to meet us, and in a clear ringing voice said, "Come in men, come in" when we entered the room you went to the side of your dear friend [Lovejoy] *and raised the napkin from his face and pointing to it you said "see your work*

Post-Bellum

brave men" one glance was sufficient, and we hurriedly left you alone with the Dead. I said alone this is not strictly true, there was one man [Royal Weller, who had been wounded by the mob], *who could not run and was left with you.*

Hoping that with all its sad memories, you may live to see many more 7th of November, I am,

Yours truly,
W.C. Quigley

Hurlbut sold his Upper Alton home to Benjamin and Helen Messenger after the death of his wife in 1884 and went to live with his daughter, Francese, and her husband, Ira Hobart Evans, in Austin, Texas. He surely appreciated the irony of an ardent abolitionist spending his final days in a former slaveholding state that had thrown in with the Confederacy.

He died at the Evanses' home on March 31, 1885, and his body was returned to Alton for burial. Most residents of Upper Alton chose to be buried in the Oakwood Cemetery, now known as the Upper Alton Cemetery. Hurlbut, however, wanted to be buried in the Alton Cemetery, where Lovejoy had been interred forty-eight years earlier. During his lifetime, Hurlbut tried without success to have a monument to Lovejoy erected in the cemetery. As fate would have it, the magnificent Lovejoy monument of 1897 was built just a short distance from Hurlbut's grave. The old abolitionist would have been very pleased indeed.

Francese Abi Hurlbut Evans often visited the home during its Messenger years and even brought her children. She entertained the Messengers with accounts of the house's role as a station on the Underground Railroad and her father's involvement in the abolitionist movement. Evans provided a link between the house's past and its present. This historic home was razed in 1957, and the site is now occupied by Calvary Southern Baptist Church.

Elijah Lovejoy

Abolitionist or Not?

Thomas Dimmock, whose father, Elijah, was an active participant in the Underground Railroad, graduated from Shurtleff College and entered journalism. He campaigned for Lincoln in the hotly contested election of 1860 and helped to rally support for the Union through his editorials and speeches during the Civil War. Dimmock's most significant act during the war years, however, had nothing to do with editorials and speeches. In 1864, Dimmock, assisted by "Scotch" Johnson, located the grave of Elijah Lovejoy in Alton's City Cemetery.

They discovered that a road in the cemetery had been built over the editor's resting place. At his own expense, Dimmock had Lovejoy's body removed and relocated in a new plot marked by a headstone that read, in Latin: "Here lies Lovejoy. Spare him now that he is buried." But Dimmock believed that Lovejoy deserved greater recognition. In 1897, largely through his efforts, a magnificent ninety-foot stone monument was erected just a short distance from Lovejoy's grave.

Dimmock was the principal speaker at the monument's dedication. While he spoke warmly of Lovejoy, he felt compelled to deny that the slain editor had been an abolitionist. "He was an anti-slavery man, but he was not an Abolitionist," Dimmock stated. "He advocated gradual emancipation." Dimmock went on to claim that Lovejoy's views "were far from harmonizing with those who proposed the immediate removal of slavery, with or without the consent and assistance of the masters."

I was initially puzzled as to why Dimmock, who certainly knew better, deliberately deceived the audience that day. Later, however, research convinced

Thomas Dimmock led the drive to erect a monument to Elijah Lovejoy and spoke at the monument's dedication. *Courtesy of Cathy Bagby.*

me that Dimmock had no choice, if he wanted the people of Alton to respect the monument that would honor Lovejoy's memory. Abolitionists were reviled in the America of 1897 and blamed for instigating the Civil War by their uncompromising opposition to slavery. About 2.1 million Northerners and 880,000 Southerners took up arms during the Civil War. An estimated 620,000 soldiers died—about 2 percent of the population at the time, according to Drew Gilpin Faust's *This Republic of Suffering: Death and the American Civil War*. This figure is made even more horrifying if we consider that losing 2 percent of our current population in a war would mean suffering 6 million combat deaths. A Civil War soldier had a 1 in 15 chance of being killed. By contrast, American military personnel in World War II—a global conflict with multiple fronts—faced a 1 in 89 chance of death, while the Vietnam War presented odds of 1 in 185. Of all our nation's conflicts, the Civil War carried the worst odds for survival.

Modern medical science was in its infancy during the 1860s, and the germ theory of disease had not yet been accepted. Epidemics of measles, mumps and smallpox swept through camps, while poor sanitation gave rise to dysentery and typhoid. Twice as many Union troops died from disease as from combat wounds.

Battles that raged across farms meant numerous civilian casualties. Women and even children were subject to reprisals during guerrilla warfare. Food shortages in parts of the South led to starvation. Historian James

Post-Bellum

McPherson estimated that as many as fifty thousand civilian deaths occurred during the Civil War. Still, such horrendous suffering was made bearable by the belief, held by most Union supporters, that victory would herald a glorious new era for the United States. Karen Armstrong, in her *The Battle for God*, notes that many Northerners believed an American utopia would emerge from this conflict.

Post–Civil War America, however, didn't even come close to realizing this anticipated paradise. The southern states eventually overthrew Reconstruction and established white supremacist governments that deprived freed blacks of their rights. Increased industrialization in the North created a wretchedly exploited working class that was forced to dwell in foul slums. Instead of the promised utopia, as Armstrong points out, the northern states underwent a swift and painful transition from an agrarian to an industrialized society. Many northerners felt betrayed and questioned whether the horrors of the Civil War had been endured in vain. The abolitionists made convenient scapegoats. In *The Metaphysical Club*, Louis Menard remarks that, for many white Americans, abolitionists were the villains of the century.

The United States in 1897, when Dimmock spoke at the Lovejoy monument's dedication, was a nation that had largely repudiated the idealism and humanitarianism of the abolitionists. The U.S. Supreme Court in 1896 legalized segregation by its *Plessy v. Ferguson* ruling. In his speech delivered at the 1896 opening of the Museum of the Confederacy in Richmond, Virginia, Confederate general Bradley T. Johnson proclaimed that the emancipation of Negroes had been the crime of the century. There was little criticism of such a blatantly racist remark among white Americans—either southerners or northerners. Just a year after Dimmock's address, the Supreme Court's decision in *Williams v. Mississippi* disenfranchised blacks living in the South.

No abolitionist could be honored in the America of 1897, so Dimmock was forced to deny Lovejoy's commitment to the immediate liberation of all slaves. We can only speculate whether Dimmock also felt compelled to deny the abolitionism of his own father, who had harbored fugitive slaves in the Dimmock home on Second Street in Alton.

Alton was no exception to this rising tide of racism in the United States. Like many other Illinois communities in the first half of the twentieth century, it openly flouted state law by maintaining segregated public schools below the high school level. African Americans who wanted to watch a movie at the old Grand Theater in downtown Alton were relegated to seats in the balcony, which some whites contemptuously called "nigger

Abolitionism and the Civil War in Southwestern Illinois

The monument to Elijah Lovejoy is located just a short distance from his grave in Alton's City Cemetery.

heaven." Downtown stores refused to allow blacks to try on clothes before purchasing them. Black families couldn't dine at the lunch counter of Kresge's Variety Store.

Local civil rights activists, many of them taking Lovejoy as their inspiration, struggled mightily to eliminate Alton's entrenched segregation and discrimination. John Gill, who served as the minister at Alton's First Unitarian Church from 1944 to 1950, wrote the first full-length biography of the slain newspaper editor: *Tide Without Turning*, published by Starr King Press in 1958. Ironically, Gill had been dismissed from his position at the Alton church in 1950 for his activism in the local civil rights movement. Lovejoy would have been pleased to know that his biography had been written by someone with such a strong commitment to equality and justice, although Gill's book emphasized Lovejoy's commitment to freedom of the press rather than his abolitionism.

Most area residents celebrated Lovejoy as a martyr to the First Amendment rather than an abolitionist until well into the 1950s. This denial of historical reality frequently baffled and exasperated nonnatives of southwestern Illinois. R.V. Cassill, who later went on to enjoy a distinguished career as an author and professor at Iowa, Columbia and Brown, taught at the old Monticello College in Godfrey, Illinois, from 1946 to 1948. His first novel, *The Eagle on the Coin*, published by Random House in 1950, is based on people and events in the Alton of the late 1940s. Riverton (Alton) is a small midwestern city where an abolitionist named Ezekiel Mountwood (Lovejoy) was murdered in the nineteenth century. The protagonist (Cassill), who teaches at a junior college (Monticello), dismisses the locals as "frightened boobs" who refuse to acknowledge the fact that Mountwood was murdered for advocating abolitionism. Cassill portrays Riverton as a city where, much like Alton, racism and segregation are deeply embedded.

The Lovejoy biographies by Merton Dillon (1961) and Paul Simon (1964), however, unabashedly identified Lovejoy as an abolitionist, while the burgeoning civil rights movement proudly claimed the murdered editor as a patron saint. The subterfuge begun out of necessity by Thomas Dimmock in 1897 finally had been superseded by the truth. Altonians and other residents of southwestern Illinois now readily—and proudly—acknowledged that Elijah Parish Lovejoy was indeed an abolitionist and lost his life for advocating the immediate emancipation of slaves.

The Sam Davis 803 Chapter of the United Daughters of the Confederacy

The prison cemetery in North Alton fell into neglect after the Civil War, and the wooden stakes that had been used to mark the location and identity of each corpse in the trenches that served as graves were stolen for souvenirs or firewood. The site was fenced with barbed wire and again used as a cow pasture.

This was intolerable for a small group of area women whose relatives had served the Confederate cause. These women organized the Sam Davis 803 Chapter of the United Daughters of the Confederacy, which was officially chartered by the national UDC on May 30, 1904. It chose the name of its chapter to honor a young Tennessee Confederate who was apprehended behind Union lines and chose execution by hanging rather than reveal the identity of the trusted source who had supplied him with sensitive Union documents.

Founded in 1894 as the National Association of the Daughters of the Confederacy and renamed the United Daughters of the Confederacy in 1895, this organization's membership consists of women who are descended from "men and women who served honorably in the Army, Navy and Civil Service of the Confederate States of America or gave Material Aid to the Cause." The UDC is still very much in existence and maintains its headquarters in Richmond, Virginia.

Although Alton's newspaper contains no mention of this chapter's founding, the edition for May 30, 1904 carried a brief article noting that representatives of the St. Louis UDC chapter intended to visit the North

Alton cemetery on June 3 to decorate its graves. The article stated that the St. Louis women had been unable to attend the previous year's ceremony due to a flood, "but Alton people carried out the program in their absence." This clearly indicates that the graves of Alton's Confederate dead were decorated annually years before the founding of Alton's Sam Davis 803 Chapter.

June 3—the birthday of Jefferson Davis—is Confederate Memorial Day. It was instituted to honor those who served in the Confederate armed forces and is still observed in southern states. The Sam Davis Chapter decided that it should be observed in Alton. Its members invited Judge J.B. Ganit of the Missouri Supreme Court to deliver an address at the North Alton cemetery on Confederate Memorial Day in 1906. They had plans for that all-but-forgotten graveyard.

One of the stated objectives of the UDC is "to honor the memory of those who served and those who fell in the service of the Confederate States of America." We may surmise that the Sam Davis 803 Chapter was founded for the express purpose of reclaiming the resting place of those Confederate prisoners of war who were buried in such ignominious anonymity.

An act of Congress, passed in 1906, appropriated $200,000 to mark the graves of Confederates who died in Northern prisons. Just a year later, William Elliott visited Alton and set up a makeshift office in the old Madison Hotel. Elliott, a Confederate veteran, had represented a South Carolina congressional district for fourteen years. Now retired from politics, he had been appointed to identify Confederate cemeteries and make certain that monuments were erected. Elliott revealed that two old volumes had been discovered in the War Department that listed the names, companies and regiments of every Confederate who died while incarcerated in the Alton prison. He was confident that, working with the Sam Davis Chapter and older Alton residents who had knowledge of the burials, he could identify the graves of the inmates interred in the cemetery. His goal was to "authorize the placing of marble headstones on each grave."

As visitors to the cemetery know, the Confederates are commemorated by a stone obelisk, erected in 1909, that lists the names and military units of the dead who rest there and on Smallpox Island. Although no known record exists as to why Elliott and the Sam Davis Chapter members were unsuccessful in placing marble headstones on each grave, we may safely surmise that it proved impossible to determine where each prisoner had been buried. The wooden stakes marking the graves had long since been burned in stoves and fireplaces, while area residents who had witnessed the burials were either deceased or afflicted with the failing memory of old age.

Post-Bellum

This obelisk in North Alton's Confederate Cemetery commemorates the Rebel dead who are buried there.

The new cemetery was greatly enhanced in 1910 when the Sam Davis Chapter had an entranceway with iron gates built at the graveyard. These lines from Sir Walter Scott's "The Lady of the Lake" are inscribed on one of the gate's stone pillars:

Soldier, rest thy warfare o'er,
Sleep the sleep that knows
Not breaking;
Dream of battlefield no more,
Days of Danger, Nights of Waking.

A report submitted by Virginia Gathright Lee, president of the UDC Illinois State Division, to the Sixteenth Annual Convention of the United Daughters of the Confederacy, which was held in Houston, Texas, in 1909, noted that the Alton chapter had only fifteen members. Nonetheless, it engaged in numerous activities, such as giving $115 to a Confederate veteran for rent and groceries and helping another veteran find work, in addition to giving him financial assistance. These determined women also gave $5 for a railroad ticket to yet another veteran who was stranded in Alton and wanted to reach his daughter, who lived in another city. The Sam Davis Chapter, according to Lee's report, had given $200 to charity during the previous year and responded to appeals from sister chapters. It contributed $5 toward construction of a monument in Arlington National Cemetery to honor the Confederate dead interred there.

The Sam Davis Chapter obtained permission from Alton's YMCA to place a case of "Southern books" in its library. This was a "great privilege," since Alton's public library "has but few books by Southern authors." Lee noted that the YMCA president was a southerner whose term of office would soon expire, so the opportunity for the Sam Davis Chapter to place additional books in the library probably would not occur again. Unfortunately, Lee failed to mention the titles of these books, so we have no idea whether they were works of history, biographies or novels. Alton has not had a YMCA for many years, so we may assume that these books were discarded long ago.

Lee's report also underscored the success of the Sam Davis Chapter in reclaiming the North Alton cemetery. The land had been used as a cow pasture, and "during the last few years this noble little band of southern women…has been trying against great discouragements to reclaim this desecrated spot." While the obelisk had been erected by the federal government, the bronze plaques listing the names of the Confederate dead

were not yet installed. Present-day Rozier Street, which runs by the cemetery, didn't exist at the time. The report cited the need for building a road that would lead to the cemetery.

The cemetery itself stood in dire need of landscaping. Lee observed that the four acres had an uneven surface that was caused by the graves' depressions. The land needed to be plowed, harrowed and rolled before grass seed was sown. The Sam Davis Chapter planned to have a memorial gate installed at the cemetery's entrance but currently had just $800 in the bank. Raising funds for the cemetery's restoration would be difficult, Lee stated, with "there being such a strong prejudice against the South in Alton." Lee was not exaggerating. The fact that area residents had allowed the North Alton cemetery to be used as a manure-strewn cow pasture for decades attested to their degree of contempt for the men buried there. The Sam Davis members undoubtedly had little local support in their campaign to honor the Confederate dead.

Lee made an impassioned appeal to the national UDC to bolster the efforts of the Sam Davis Chapter to make the cemetery a suitable resting place for those interred in its soil. One run-on sentence in her report composed an entire paragraph and deserves to be quoted in its entirety.

> *Almost the whole South is represented in this cemetery by its dead, and I feel that I am justified in making an appeal through the General Assembly to Southern women not to forget their dead in the North, whose martyrdom and suffering was almost inconceivable, and who through the fortunes or misfortunes of war, were not permitted to gloriously die under the folds of the flag they loved and upon the soil of their Southland, to be eulogized in song and story and their resting places annually decorated by loving hands but were doomed to waste away with disease and neglect, far from the land which loved them and to lie for these many years almost unwept, unhonored, and unsung being no less martyrs and heroes for the cause of the South than those who died at the battle's front.*

Lee concluded her report by reminding the delegates that the Illinois Division of the UDC was "an infant, only two weeks old, and although this report is hastily written, I am proud to submit it, as the first president." Alton's Sam Davis 803 Chapter, she proudly proclaimed, "is imbued with new life since the organization of a State division."

Actually, the Illinois State Division owed *its* life to the Sam Davis Chapter. Lee's report designated the Sam Davis Chapter as "the charter chapter

of Illinois," which meant that it was the first UDC chapter in the Prairie State. When Illinois contained the required number of chapters—including a "Stonewall" chapter in Chicago—the Sam Davis members called a convention to organize a state division. This convention was held in Alton on October 4–5, 1909. Mrs. G.J. Grommet, who was the president of the Sam Davis Chapter, served as the Alton delegate at this convention. She was elected custodian of the Cross of Honor of the newly formed Illinois State Division, while a Mrs. Long of Alton (no first name given in the report) was chosen to serve as second vice-president. Delegates to the convention were "handsomely entertained" by the women of the Sam Davis Chapter, according to Lee, and taken to visit the North Alton cemetery.

A *Telegraph* article dated June 1, 1910, stated that members of the Sam Davis 803 Chapter planned to observe Confederate Memorial Day on June 3 at the cemetery. Although the newspaper carried no follow-up story describing the observance, we may assume that the chapter held a ceremony to honor those buried in the cemetery.

Lee, in her 1909 report to the UDC convention, had stated that the Sam Davis Chapter was imbued with new life since the organization of the Illinois State Division. That "new life," however, extended for just eight more years after her address.

The Sam Davis Chapter last paid dues to the national organization in 1917. The officers of the chapter that year were: Mrs. Mary Young, president, who resided at 2229 West Brown Street; Mrs. Lucy Merriwether, secretary, 1717 Central Avenue; and Mrs. Dan Miller (no address given). Chapter members included Mrs. Sam Basse, Pauline Davis Collins, Anne Hill Cunningham, Mary Miller Cunningham, Sada Blake Grommet, Elizabeth E. Hill Hearne, Elise Pinero Linkogle, Minnie Kercheval Long, Mary E. Miller and Mary A. Dixon Young.

It is uncertain when and why the chapter formally disbanded. While its existence was brief, the Sam Davis 803 Chapter played a decisive role in preserving an important historical site in southwestern Illinois.

The Rocky Fork Church

The Rocky Fork New Bethel African Methodist Episcopal Church still exists in Godfrey, proudly bearing witness to the faith of those long-ago escaped slaves. The original church building was replaced by a new structure in 1926. Andrew Hawley, grandson of Don Alonzo Spaulding, established Camp Hawley in 1921 on some of the land once used by Rocky Fork residents. He deeded Camp Hawley to the Boy Scouts in 1924. Additional parcels of land over the years doubled the size of the camp, which was renamed Camp Warren Levis. Boy Scout camp counselors often reminded the boys using this land that many of the paths they followed were once slave trails.

Located on Rocky Fork Road just a short distance from Camp Warren Levis, the church suffered vandalism in the 1970s and was destroyed by arson in 1988. Community members, black and white, were outraged and rallied to rebuild the church. The National Park Service in 2002 designated a 287-acre tract of land in the Rocky Fork area as part of the Underground Railroad Network to Freedom. The land, which is still owned by the Boys Scout Trails West Council, is one of just three sites in Illinois that are officially verified as part of this network. Historians of the Underground Railroad state that Rocky Fork is second only to Cincinnati in its significance.

While there is no monument in the River Bend to commemorate the Underground Railroad, the homes and buildings that served as stations remind residents and visitors of that perilous journey to freedom. The official

recognition of Rocky Fork's significance in the struggle against slavery also serves as a memorial. Still, the best testament to this community's role in the Underground Railroad rests with every African American whose ancestors first reached freedom when they arrived in southwestern Illinois.

The Alton Prison and Smallpox Island

The Alton prison was closed after the Civil War and never reopened. Its stones were taken away over the years and employed for a variety of purposes. For instance, a number of the stones were crushed and then used to pave the streets of Crystal City, Missouri. Local residents in need of stone also made use of the abandoned prison. In a supremely ironic twist, the prison yard, where once men walked or stood in hopelessness, was transformed into Uncle Remus Park, which was named after the character created by Joel Chandler Harris. The park has not existed for many years.

Several Confederate veterans who had been incarcerated in Alton returned to the city because they wanted stones from the prison to use as their grave markers. Samuel Breckinridge of Murfreesboro, Tennessee, came to Alton in 1937 on such a mission. He claimed that in 1863 he had escaped from the prison by hiding in a coffin that was loaded in a wagon and taken to the North Alton cemetery. Breckinridge said that he broke out of the coffin when he heard the wagon leave.

Stones from the prison continued to disappear, and by the 1970s, only a few remained. In 1973, the last stones were arranged into the present memorial on William Street. The area once occupied by the prison is now a vast parking lot.

Floods that undulated Smallpox Island in the years following the Civil War undoubtedly washed away some of the interred bodies. But the dead generally rested in peace until the construction of the original Locks and Dam 26 in the 1930s. The work crews digging into the island began uncovering skeletons.

Abolitionism and the Civil War in Southwestern Illinois

Above: Rows of cells in a wall of the Alton prison were exposed as the structure was being demolished. *Courtesy of the* Alton Telegraph.

Below: Former Confederate prisoner of war Samuel Harrison of Missouri returned to the prison site in 1935 to select a stone for his grave marker. *Courtesy of the* Alton Telegraph.

Post-Bellum

Above: This monument at the Lincoln-Shields Recreation Area in West Alton, Missouri, commemorates the prisoners who died in the isolation hospital and were buried on Smallpox Island.

Below: These few limestone blocks mark the site of the Alton prison, where at least 11,764 men and women were incarcerated during the Civil War.

Some older area residents still talk about seeing the unearthed bones of the Civil War dead. As word spread about the grisly discovery, a young reporter for the *Alton Evening Telegraph* rented a rowboat to investigate. Tying his craft to the roots of a maple, he saw skulls entangled in the tree's roots. He dug into the bank and found more bones. The reporter saw no evidence of caskets but found a flagstone that might have been used for a grave marker.

The discovery of these skeletons had no effect on the construction schedule. Work continued uninterrupted, with no attempt at preservation of the Civil War dead. The United States was struggling through the Great Depression, and the dam was vitally needed to facilitate river traffic. Economic necessity took priority over historical investigation or even reverence for the deceased. The skeletons were simply reburied on the island. When the completion of Locks and Dam 26 raised the water level, Smallpox Island and the skeletons it held were submerged by the Mississippi and remain so to this day.

Well, perhaps not *all* the skeletons. A remnant of old Locks and Dam 26 still stands near the monument. It was not dynamited along with the rest of the outdated structure when the new dam was completed in 1994. Although its stairs lend visitors a fine view of the river and surrounding countryside, it was not left intact just to accommodate tourists. Some inmates are buried in the ground that supports it. Had it been blown up, skeletons would have been destroyed.

The U.S. Army Corps of Engineers and the Rosenbloom Monument Company of University City, Missouri, in 2001 erected a 6.5-foot, thirty-nine-thousand-pound monument dedicated to those inmates who died on Smallpox Island and were buried there. Located in the Lincoln-Shields Recreation Area of West Alton, Missouri, it is just downstream from the site of Smallpox Island. The five-sided monument lists the names of the 262 men and 1 woman who died in the island's isolation hospital for prisoners and were buried on the island.

Brooklyn

On August 18, 1891, Brooklyn's new post office was named Lovejoy to distinguish it from a town in Schulyer County that was also named Brooklyn. A Brooklyn school was also named Lovejoy. One scholar observed that Lovejoy was perceived as a patron saint in this community. Contemporary residents, however, prefer that their town be called Brooklyn.

Brooklyn today is a far cry from the community envisioned by Priscilla Baltimore and the other African Americans who crossed the Mississippi so many years ago. The town's population in 2000 was just 675, while its only real source of revenue comes from establishments that provide what is euphemistically called "adult entertainment." But Brooklyn's residents take pride in their town's role as a beacon of freedom in a nation that trafficked in shackled human beings. The research of historians and archaeologists has done much to publicize Brooklyn's significance.

University of Illinois archaeologists have begun excavating the backyards of Brooklyn residents to uncover artifacts from the town's past. Relics discovered include a broken piece of teacup and shards of extremely thin window glass. Archaeologist Joseph Galloy stated that the bluish-glazed exterior dated the cup to the 1780–1830 period. The thin window glass is representative of an earlier America, since later window glass is thicker.

The Brooklyn Historical Society was founded in 2007 to help preserve the town's heritage. Roberta Obadan, president of the society, recalled the Brooklyn of decades past, when the town had grocery stores, movie theaters and jazz clubs. In those days, Obadan noted, Brooklyn was such a safe

community that residents felt no need to lock their doors. The strip clubs and adult bookstores sprang up only after Brooklyn entered economic decline.

Mrs. Juanita Clemson coined the town's motto: "Founded by Chance, Sustained by Courage." Brooklyn will endure and well deserves its place in the pantheon of liberty.

The Hamilton School in Otterville

Regional historian Eileen Smith Cunningham, who graduated from Shurtleff College in 1947, recalled two classmates who attended the college on scholarships provided by the George Washington Education Fund. The students were Muriel Cannon, a public speech and music major, and John Paul Jackson, who majored in education.

The original schoolhouse was built of locally quarried stone. The two-story structure, which measured twenty-eight by sixty-six feet, held its first classes in 1836. This building was razed in 1870, and the present building was constructed on the site.

Human rights activists have long recognized the Hamilton School as a freedom landmark. Buses brought people from Alton and other nearby communities to visit the school during the height of the civil rights movement in the 1960s. The Alton branch of the NAACP held a wreath-laying ceremony at the Hamilton School every year from 1934 to 1967.

Students at the Hamilton School were taught that their future alma mater was the first tuition-free integrated school in the United States. Area residents and even many historians long shared that belief. Evidence exists, however, that such may not be the case.

Lila Flautt-Melcher, who has thoroughly researched the Hamilton School, noted that early integrated schools existed in Maine and New Hampshire. She also stated that, prior to the Hamilton School's founding, tuition-free schools existed in Maine, Connecticut, New Hampshire, Maryland, Ohio, Alabama and Louisiana.

Very well, then; can we at least affirm that the Hamilton School was the first integrated school in Illinois? Perhaps—and perhaps not. Old records indicate that Alton, founded in 1818, contained a public school in 1821 that was open to "every child of suitable age." If "every child" indeed meant any child regardless of race, then the Hamilton School was not our state's first integrated school.

Even if the school hasn't a legitimate claim to any uncontested "firsts," it possesses indisputable historical significance. Besides Washington, the Hamilton School can boast of other distinguished alumni. Stephen White, a successful banker and attorney, was a member of the New York Stock Exchange and served a term in Congress. He was also an astronomer and served as the first president of the American Astronomical Society. William McAdams and John Dougherty embarked on careers in archaeology and conducted numerous excavations of Native American sites in this area. McAdams Peak at Pere Marquette State Park in Grafton is named for McAdams. His collection of Native American artifacts is housed in the Smithsonian Institution.

Perhaps the Hamilton School's most distinguished alumnus was John Hamilton, who achieved acclaim in the fields of medicine and public health. A Civil War veteran, Hamilton served as U.S. surgeon general from 1879 to 1891 and worked to contain the spread of disease through effective quarantine policies. He later joined the faculty of his alma mater, Rush Medical College, and edited the *Journal of the American Medical Association*. He concluded his career as superintendent of the Illinois State Hospital for the Insane in Elgin, Illinois. He is buried in Arlington National Cemetery.

Classes were held at the Hamilton School until 1971. The old building was in such a state of disrepair that it was condemned under the Illinois Safety Code. The school has been renovated and now serves as a museum that features much memorabilia about the Hamilton School and the Otterville area. In addition to the school, Washington's monument to Silas Hamilton and the three grave sites, visitors can also see an outdoor display that features the original bell that once summoned students to their classes. The Hamilton Primary School Festival is held annually on the third weekend of September on the school grounds at 107 East Main Street in Otterville.

Philip Mercer

Minister, Author, Confederate Partisan

Born in London, England, on May 26, 1888, Philip Mercer immigrated to the United States at age eighteen and took a divinity degree at Chicago Theological Seminary in 1918. He served as minister at several Congregational and Unitarian churches in Wisconsin and Minnesota before being called to serve as pastor at Alton's First Unitarian Church in 1929. Mercer's biography of Confederate officer John Pelham, titled *The Life of the Gallant Pelham*, was published that same year by the J.W. Burke Company of Macon, Georgia, although an *Alton Evening Telegraph* article announcing his call to the church's pulpit makes no mention of it. His authorship of the book remains largely unknown in southwestern Illinois to this day.

Mercer notes in his preface that the absence of a book devoted exclusively to Pelham's life motivated him to write the work. After mentioning written sources consulted during his research, Mercer states that he "visited the scenes of Pelham's early life in Calhoun County, Alabama," as well as "Virginia scenes and battlefields familiar to him during his war experiences." He also interviewed Samuel C. Pelham, John Pelham's nephew, "for facts on his uncle's early life." Among others, Mercer expresses gratitude to Professor John Talbot of the State Teachers College in St. Cloud, Minnesota, for critiquing the manuscript. Mercer probably made Talbot's acquaintance while serving at churches in that state.

The first sentence of the first paragraph states, "The name Pelham is one of the most illustrious in English history." This might explain Pelham's fascination for the London-born Mercer, although precisely how he learned

about a Confederate officer who died twenty-five years before his birth remains unknown. Born in Alabama in 1838, John Pelham resigned from West Point shortly before he was scheduled to graduate in order to return South and serve in the Confederate army as an artillery officer. His youth and boyish appearance brought him nicknames such as "the boy major" and "the boy artillerist." Pelham's service at the Battle of Fredericksburg persuaded Robert E. Lee to bestow the young warrior with a considerably more distinguished title—"the Gallant Pelham."

Pelham also earned the admiration of Confederate general Stonewall Jackson, who boasted, "With a Pelham on each flank, I believe I could whip the world." When Pelham was killed during the Battle of Ford's Ferry, Virginia, in March 1863, Mercer writes that General J.E.B. Stuart wept, kissed the fallen warrior's brow and uttered, "Farewell." Stuart named his daughter, born in October of that year, Virginia Pelham Stuart in honor of John Pelham.

The Life of the Gallant Pelham has a decidedly pro-Dixie slant. Mercer refers to the Civil War as "the War Between the States," which is the term preferred by Southern partisans. His writing style is often florid. When describing the character of J.E.B. Stuart, Mercer tells us, "His disposition was joyous; his soul overflowed with song and sentiment." Mercer also includes what he terms "an amusing account" about Pelham and two other Confederate officers obtaining shelter in the cabin of a free black during a snowstorm. Initially turned away, Pelham cursed the black man as a stupid old nigger and persuaded the other two men to pass themselves off as Robert E. Lee, his staff officer and the French ambassador. The ruse worked, and they were admitted to the cabin.

Mercer's unabashed sympathy for the Old South can be attributed to his ethnic roots. Great Britain seriously considered extending diplomatic recognition to the Confederacy during the early years of the American Civil War. An independent South would have seriously weakened the United States as an international rival. On a more philosophical level, the English aristocracy identified with the South and regarded it as the flower of Anglo-Saxon culture. Philip Mercer was certainly no aristocrat but seems to have been a latter-day adherent of this view. He had been born too late to come to the aid of what he regarded as a patrician, genteel civilization during its war for independence, but he at least could celebrate one of its warriors in a book.

The Pelham biography was Mercer's only book. For reasons unknown, Philip Mercer committed suicide on November 19, 1934. His body was found hanging in the church on November 20 by his landlord, from whom

Post-Bellum

Mercer had rented a room at 319 East Fourth Street in Alton for five years. The author of Pelham's biography had written no suicide note.

Mercer might have been working on another book, since his estate assets listed a manuscript titled "Forrest, the Wizard of the Saddle." The title refers to Confederate general Nathan Bedford Forrest's nickname. Unlike many other Confederate generals, Forrest could claim no distinguished lineage. Before the Civil War, he had worked as a slave trader. Forrest's troops massacred African American Union soldiers who had surrendered at Fort Pillow, Tennessee, in 1864. After the war, Forrest served as the first grand wizard of the Ku Klux Klan.

Mercer's papers also contained letters from one Dorothy Cole of Minneapolis, Minnesota, which revealed that she and Mercer had planned to marry in the spring of 1935. Members of the church he had served for six years had no idea their minister was even engaged. By all accounts, Mercer had been an extremely private person, given to spending much time in his study at church and rarely discussing personal matters. He was known to attend symphony concerts and other musical events in St. Louis. It's unclear whether members of the congregation were aware that their minister was a published author.

Despite its pro-Confederate bias, *The Life of the Gallant Pelham* is recognized as a significant work of scholarship and has been reprinted twice by other publishing firms. Copies of the 1929 edition have sold for over $500. Philip Mercer, the troubled English immigrant who was so fascinated by Confederate officers, left an enduring legacy before ending his life.

Mercer and the Sam Davis Chapter of the United Daughters of the Confederacy were southern partisans in post-bellum southwestern Illinois. This writer, however, celebrates Elijah Lovejoy, Thaddeus Hurlbut, Elijah Dimmock and our region's other abolitionists, as well as those men and women who stood with the Union during the Civil War. I always make a point of visiting the memorial to Wilberforce Lovejoy Hurlbut on May 6, the anniversary of the day he went missing in action during the Battle of the Wilderness. His sacrifice for our nation and the cause of freedom will never be forgotten for as long as I am alive.

Bibliography

Works by the Author

"Alton Minister Wrote First Biography of Confederate Officer." *Alton* [IL] *Telegraph*, February 22, 2009.
"Alton Prison Housed Cross-Dressing Spy." *Alton* [IL] *Telegraph*, April 17, 2011.
"Alton's Turner Hall." *Springhouse* 25, no. 3 (n.d.).
"Alton Volunteers Kept Weapons Out of Confederate Hands." *Alton* [IL] *Telegraph*, May 15, 2011.
"Anti-slavery Society Was Founded in Upper Alton." *Alton* [IL] *Telegraph*, February 20, 2011.
"Brooklyn, Illinois: An Underground Railroad Town." *Springhouse* 25, no. 1 (n.d.).
"Elijah Lovejoy. Abolitionist Martyr." *Springhouse* 12, no. 4 (August 1995).
"Former Alton Minister Wrote First Lovejoy Biography." *Alton* [IL] *Telegraph*, December 14, 2008.
"George Washington, Silas Hamilton and Otterville's Hamilton School." *Springhouse* 25, no. 6 (n.d.).
"Governor Edward Coles and the Fight Against Slavery in Illinois." *Springhouse* 25, no. 5 (n.d.).
"The Grave of Private Collins." *Illinois* 27, no.3 (May–June 1988).

"The Grave of Private Collins." *Springhouse* 13, no. 3 (June 1996).
"The Hurlbut-Messenger House: A Lost Treasure of Downstate Illinois." *Springhouse* 27, no. 5 (n.d.).
"Illinoisan Led Charge for a National Day of Remembrance." *St. Louis Post-Dispatch*, May 5, 2004.
It Happened at the River Bend. Alton, IL: Second Reading Publications, 2007.
"The Lincoln-Douglas Debate in Alton." *Illinois* 22, no. 5 (November–December 1983).
"The Martyrdom of Elijah Lovejoy." *Illinois* 25, no.1 (January–February 1985).
"Monticello Professor Wrote Novel about Alton." *Alton* [IL] *Telegraph*, August 31, 2008.
"New Light on Smallpox Island." *Springhouse* 7, no .4 (August 1990).
"A Poignant Memorial." *Illinois* 29, no. 3, (May–June 1990).
"River Bend Had a United Daughters of the Confederacy Chapter." *Alton* [IL] *Telegraph*, August 16, 2009.
"The Sam Davis 803 Chapter of the United Daughters of the Confederacy." *Springhouse* 26, no. 6 (n.d.).
"Slave's Unusual Monument to Former Owner." *St. Louis Post-Dispatch*, February 26, 1997.
"Spirit of Lovejoy Lives On in Those Who Love Freedom." *Alton* [IL] *Telegraph*, November 3, 1996.
"Thaddeus Hurlbut: Upper Alton Abolitionist." *Alton* [IL] *Telegraph*, August 8, 2010.
"Why Lovejoy's Abolitionism Had to Be Denied." *Alton* [IL] *Telegraph*, April 18, 2010.
"Why Lovejoy's Abolitionism Had to Be Denied." *Springhouse* 27, no. 3 (n.d.).

Works That Were Useful to the Author in His Research

Allen, John W. *Legends and Lore of Southern Illinois*. Johnston City, IL: A.E.R.P. Publishers, 1985.
Alton [IL] *Evening Telegraph*. "Confederate Memorial Day." March 23, 1906.
———. "Dr. O.P.S. Plummer Is Dead." December 26, 1913.
———. "Federal Officer Here to Mark Graves." June 22, 1907.
———. "Glass Blowers' Ball." January 20, 1881.

Bibliography

———. "Going Back Fifty-Three Years: Edwardsville Editor Recalls a Visit to County Seat of Capt. Weigler, Still in Business." October 2, 1908.
———. "Mercer Estate Valued at $9000." March 8, 1935.
———. "Rev. Mercer Ends Life in Church Hall." November 21, 1934.
———. "Sale of Equipment Sounds Death Knell of Old Turnverein." September 21, 1935.
———. "Unitarians Call the Rev. Mercer to Alton Pulpit." October 21, 1929.
———. "Will Decorate Confederate Graves." May 30, 1904.
Alton [IL] Telegraph. "The Evidence." May 19, 1865.
———. "Muster Roll of the Alton Jaeger Company." May 3, 1861.
Alton [IL] Weekly Telegraph. "Decoration Day." May 12, 1871.
———. "Decoration Day." May 19, 1871.
Angle, Paul M. *Created Equal? The Complete Lincoln-Douglas Debates of 1858*. Chicago: University of Chicago, 1958.
Armstrong, Karen. *The Battle for God*. New York: Knopf, 2000.
Blanton, Deanne, and Lauren M. Cook. *They Fought Like Demons: Women Soldiers in the Civil War*. Baton Rouge: Louisiana State University Press, 2002.
Bordewich, Fergus M. *Bound for Canaan: The Underground Railroad and the War for the Soul of America*. New York: Amistad, 1995.
Bowen, A.L. "Anti-Slavery Convention Held in Alton, Illinois, October 26–28, 1837." *Journal of the Illinois State Historical Society* 20, no. 30 (October 1927).
Bringhurst, John. "A Local War Time Tragedy." In *Centennial History of Madison County, Illinois and Its People, 1812–1912*, edited by W.T. Norton. Chicago: Lewis Publishing Company, 1912.
Brunner, Will. "Island Yields Skeletons of Prison Dead." *Alton* [IL] *Evening Telegraph*, July 23, 1935.
Cassill, R.V. *The Eagle on the Coin*. New York: Random House, 1950.
Cha-Jua, Sundiata Keita. *America's First Black Town: Brooklyn, Illinois, 1830–1915*. Urbana: University of Illinois Press, 2000.
Cox, Jann. *Alton Military Penitentiary in the Civil War: Smallpox and Burial on the Alton Harbor Islands*. Alexandria, VA: U.S. Army Corps of Engineers, 1988.
Dawson, George Francis. *The Life and Services of General John A. Logan as Soldier and Statesman*. Chicago: Belford, Clarke Company, 1887.
Decker, Sylvia. "Bell Will Again Sound at Historic School." *Alton* [IL] *Telegraph*, September 14, 2007.

BIBLIOGRAPHY

Dillon, Merton. *Elijah P. Lovejoy, Abolitionist Editor*. Urbana: University of Illinois Press, 1961.

Eddy, Thomas Mears. *The Patriotism of Illinois*. Chicago: Clarke and Company, 1865.

Ellis, Cynthia. "Primary Lesson." *Alton* [IL] *Telegraph*, September 19, 2005.

Epps, Garrett. *Democracy Reborn*. New York: Henry Holt and Company, 2006.

Faust, Drew Gilpin. *This Republic of Suffering: Death and the American Civil War*. New York, Knopf, 2008.

Finch, Remy, and Edward Finch. "The Other Senator from Illinois." *Illinois* 30, no. 4 (July–August 1991).

Flaut-Melcher, Lila. *Noble Master, Noble Slave*. Hardin, IL: Campbell Publishing Company, 1993.

Forcade, Lottie. "A History of the First Unitarian Church of Alton, Illinois, 1836–1986." Unpublished paper housed in the library of First Unitarian Church of Alton.

Frost, Griffin. *Camp and Prison Journal*. Iowa City, IA: Press of the Camp Pope Bookshop, 1994.

Gill, John. *Tide Without Turning: Elijah P. Lovejoy and Freedom of the Press*. Boston: Starr King Press, 1958.

Harris, N. Dwight. *The History of Negro Servitude in Illinois and the Slavery Agitation in that State, 1719–1864*. Chicago: A.C. McClurg and Company, 1904.

Hazelwood, Mary. "Ex-slave and Hamilton Set Finest Example of Christian Brotherhood." *Alton* [IL] *Evening Telegraph*, May 29, 1971.

Hoffman, Judy. *God's Portion: Godfrey, Illinois, 1817–1865*. Nashville, TN: Cold Tree Press, 2005.

Holland's Alton City Directory for 1868–69.

Hudson, J. Blaine. *Encyclopedia of the Underground Railroad*. Jefferson, NC: McFarland and Company, 2006.

Hull, Herbert A. "Messenger and Allied Families." *Americana Illustrated* 20, no. 4 (1926).

Ingram, Larry. "Preserving History Takes Work." *Edwardsville* [IL] *Journal*, June 24, 2008.

Kime, Jack L. "A Fork in the Road: Confederate Prisoners in Illinois, Part 1." *Troy* [IL] *Tribune*, April 19, 2007.

———. "A Fork in the Road: Confederate Prisoners in Illinois, Part 2." *Troy* [IL] *Tribune*, April 26, 2007.

Krug, Mark M. *Lyman Trumbull: Conservative Radical*. New York: A.S. Barnes and Company, Inc., 1965.

Lee, Virginia Gathright. "Report of the President of the Illinois State Division to the Sixteenth Annual Convention of the United Daughters of the Confederacy, held in Houston, Texas, October 19–22, 1909."
Maddox, Teri. "Best Kept Secret in Illinois." *Belleville* [IL] *News-Democrat*, May 20, 2001.
Menard, Louis. *The Metaphysical Club*. New York: Farrar, Straus, and Giroux, 2001.
Mercer, Philip. *The Life of the Gallant Pelham*. Macon, GA: J.W. Burke Company, 1929.
Moon, Jill. "Otter Creek Historical Society Celebrates First School Integration." *Alton* [IL] *Telegraph*, September 14, 2009.
Morwood, Burton Westlake. "A Modern Saga of an Old-Time Upper Alton House." Unpublished paper, dated April 9, 1971, in the library of the author.
Nedde, Paul, and Ann Perry. "Alton Was Vital Link in Nation's Underground Railroad." *Alton* [IL] *Evening Telegraph*, July 2, 1976.
Nolan, Donna J. "Underground Railroad Trail Led through Brighton." *Alton* [IL] *Telegraph*, October 9, 2000.
Norrish, Dick. "Coles Kept Illinois Free State." *Edwardsville* [IL] *Intelligencer*, May 4, 1978.
Norton, W.T. *Edward Coles: Second Governor of Illinois*. Philadelphia: J.B. Lippincott, 1911.
Owen's City Directory and Classified Business Directory of Madison County for 1874.
Phinney, Mary Allen. *A Brief History of Ebenezer Phinney (of Cape Cod) and his Descendants from 1637 to 1947*. Rutland, VT: Tuttle Publishing Company, Inc., 1948.
Political Debates Between Hon. Abraham Lincoln and Hon. Stephen A. Douglas. Columbus, OH: Follett, Foster and Company, 1860.
Ress, David. *Governor Edward Coles and the Vote to Forbid Slavery in Illinois, 1823–1824*. Jefferson, NC: McFarland and Company, Inc., 2006.
Roske, Ralph J. *His Own Counsel: The Life and Times of Lyman Trumbull*. Reno: University of Nevada Press, 1979.
Simon, Paul. *Freedom's Champion: Elijah Lovejoy*. Carbondale: Southern Illinois University Press, 1994.
Stauffer, John. *Giants: The Parallel Lives of Frederick Douglass and Abraham Lincoln*. New York: Twelve, 2008.
Stetson, Charlotte. *Alton, Illinois—A Pictorial History*. St. Louis, MO: G. Bradley Publishing, Inc., 1986.

Totten, Carla. "Alton Military Prison." Master's thesis, Southern Illinois University at Edwardsville, 1983.
United States Biographical Dictionary. "Thaddeus Hurlbut." N.p., 1876.
Washburne, E.B. *Sketch of Edward Coles: Second Governor of Illinois.* Chicago: Jansen, McClurg and Company, 1882.
Whaley, Dave. "Site Recognized as Part of Underground Railroad." *Alton* [IL] *Telegraph*, August 15, 2002.
White, Horace. *The Life of Lyman Trumbull.* Boston: Houghton Mifflin Company, 1913.

Index

A

Alton, IL 78, 79, 80, 81, 83, 85, 86, 87, 88, 91, 92, 93, 95, 96, 97, 99, 100, 104, 107, 108, 109, 111, 113, 119, 120, 121, 123, 124, 125, 127, 129, 130, 132, 133, 134, 137, 143, 145, 147
Alton Observer 42, 43, 44, 59
Andersonville 113

B

Baltimore, Priscilla 27, 28, 141
Birkbeck, Morris 20
Borders, Sarah 64
Brighton, IL 52
Brooklyn 27, 28, 29, 141, 142
Brown, John 47

C

Cairo, IL 81
Camp and Prison Journal 113
Carlinville, IL 52
Cassill, R.V. 127
Civil Rights Act of 1866 115, 118

Coles, Edward 10, 15, 16, 17, 18, 19, 20, 21, 22, 23, 24, 25
Coles, Robert 24

D

Decoration Day. *See* Memorial Day
Democratic Party 66, 117
Dimmock, Elijah 10, 51, 55, 57, 123, 147
Dimmock, Thomas 123, 124, 125
Dobelbower, John 99, 100
Douglas, Stephen A. 64, 69, 70, 71, 72, 104

E

Edwards, Ninian 17
Edwardsville 10, 17, 18, 19, 25, 52, 86, 159
Emancipation Proclamation 54, 99, 104, 113
Emerson, Ralph Waldo 47

Index

F

Federal military prison in Alton 87
Fidelity, IL 100, 101
First Unitarian Church of Alton, IL 38, 127, 145
Forrest, Nathan Bedford 95, 96, 147
Frost, Griffin 91, 92, 93, 94, 96, 113, 114
Fugitive Slave Act of 1793 49
Fugitive Slave Act of 1850 49

G

Gill, John 38, 127
Godfrey 36, 52, 65, 127, 135
Grand Army of the Republic 111
Gratiot Prison 92, 113

H

Haley, William D'Arcy 71
Hamilton School 34, 36, 143, 144
Hamilton, Silas 31, 32, 33, 34, 36
Hope, Thomas 46, 71, 99, 100
Hurlbut, Thaddeus 10, 43, 44, 45, 46, 55, 59, 60, 61, 119, 121
Hurlbut, Wilberforce Lovejoy 60, 61

I

Illinois Anti-Slavery Society 42, 43, 50, 59

J

Jackson, Stonewall 146
Jarrot, Joseph 64
Johnson, Andrew 69, 115, 116

K

Kansas-Nebraska Act 66
Knights of the Golden Circle 99, 100
Ku Klux Klan 115, 116, 119, 147

L

Libby 113
Liberal Republican Party 117
Life of the Gallant Pelham, The 145, 146, 147
Lincoln, Abraham 10, 64, 65, 66, 67, 69, 70, 71, 72, 73, 77, 85, 94, 100, 103, 104, 123
Lippincott, Thomas 20
Logan, John A. 111
Longstreet, James 61
Lyon, Nathaniel 77, 78, 79

M

Madison, James (bishop & professor) 15
Madison, James (president) 15, 16, 20, 24
Meagher, Thomas F. 61
Medora, IL 101
Memorial Day 111, 130
Mercer, Philip 145, 146, 147
Messenger, John 19, 20, 23
Missouri State Guard 91
Mitchell, Leander 78, 79
Monroe, James 18, 23
Moore, Franklin B. 79

N

Northwest Ordinance 16, 17, 19, 24, 64, 65

O

Old Rock House 43, 50, 59, 60
Otterville, IL 31, 33, 34, 36, 144

P

Peck, John Mason 20
Pelham, John 145, 146, 147
People's Party 118
Phillips, Wendell 47
Pitman, May Ann 95, 96, 97

Index

Plummer, O.P.S. 78, 80, 81
Price, Sterling 96

Q

Quinn, William Paul 27, 28

R

Richardson, Isaac 61
Rocky Fork 36, 52, 53, 54, 135, 136

S

Semple, James 99
Shurtleff College 20, 44, 51, 61, 123, 143
Smallpox Island 10, 88, 89, 95, 130, 137, 140
Sons of Liberty. *See* Knights of the Golden Circle
Spaulding, Don Alonzo 52, 53, 135
St. Louis Observer 39, 59
St. Louis Times 38, 39
Stokes, James 78, 79, 80, 81
Stuart, J.E.B. 146

T

Thirteenth Amendment 10, 104
Trumbull, Lyman 10, 15, 63, 64, 65, 66, 67, 103, 104, 115, 116, 117, 118
Turner Hall 83, 86, 107, 108, 109, 111
Turnverein. *See* Turner Hall

U

United Daughters of the Confederacy 10, 129, 132, 147
Upper Alton 10, 20, 42, 43, 44, 51, 53, 59, 60, 61, 121

V

Vandalia, IL 19, 20, 21

W

Washington, George 32, 33, 34, 35, 36, 42, 81, 85, 100, 143, 144
Weller, Royal 46, 121

About the Author

Born in Alton, Illinois, and now residing in the village of Godfrey, John J. Dunphy is a summa cum laude graduate of Southern Illinois University at Edwardsville and attended that university's graduate school on an academic fellowship. He is a member of the SIUE School of Education's Academy of Fellows and also serves on the Executive Advisory Board of the SIUE School of Education.

Dunphy has written hundreds of articles for magazines and newspapers. His books include *Lewis and Clark's Illinois Volunteers*, *It Happened at the River Bend*, *Dark Nebulae* and *From Christmas to Twelfth Night in Southern Illinois*, which was published by The History Press in 2010. He taught writing at Lewis and Clark Community College for almost a decade and owns the Second Reading Book Shop in Alton, Illinois. Visit him in cyberspace at www.johndunphy.com and www.secondreadingbookshop.com.

Visit us at
www.historypress.net